MARTIN A. BERGER

FREEDOM NOW! FORGOTTEN PHOTOGRAPHS OF THE CIVIL RIGHTS STRUGGLE

Art, Design & Architecture Museum
University of California at Santa Barbara

University of California Press
Berkeley Los Angeles London

This catalogue was published on the occasion of the exhibition *Freedom Now! Forgotten Photographs of the Civil Rights Struggle.*

Published by
University of California Press
2120 Berkeley Way
Berkeley, CA 94704-1012
www.ucpress.edu

University of California Press
Kari Dahlgren, Acquiring Editor
Jack Young, Editorial Assistant
Janet Villanueva, Production Coordinator

Glue + Paper Workshop, LLC
www.glueandpaper.com
Amanda Freymann, Project Management and Production
Joan Sommers, Design and Typesetting
Tom Fredrickson, Editor

Color separations by Professional Graphics, Rockford, IL.
Printed and bound in China by Asia Pacific Offset.

ISBN 978-0-520-28019-9

Library of Congress Control Number 2012950750

Cover: Unidentified photographer, *Woman Resisting Arrest*, Birmingham, Alabama, April 14, 1963. Courtesy of Michael Ochs Archives/Getty Images. See number 43.

Frontispiece: Matt Herron, *Marcher in Whiteface*, Selma–Montgomery, Alabama, March 21, 1965. © Matt Herron. See number 69.

FREEDOM NOW! FORGOTTEN PHOTOGRAPHS OF THE CIVIL RIGHTS STRUGGLE

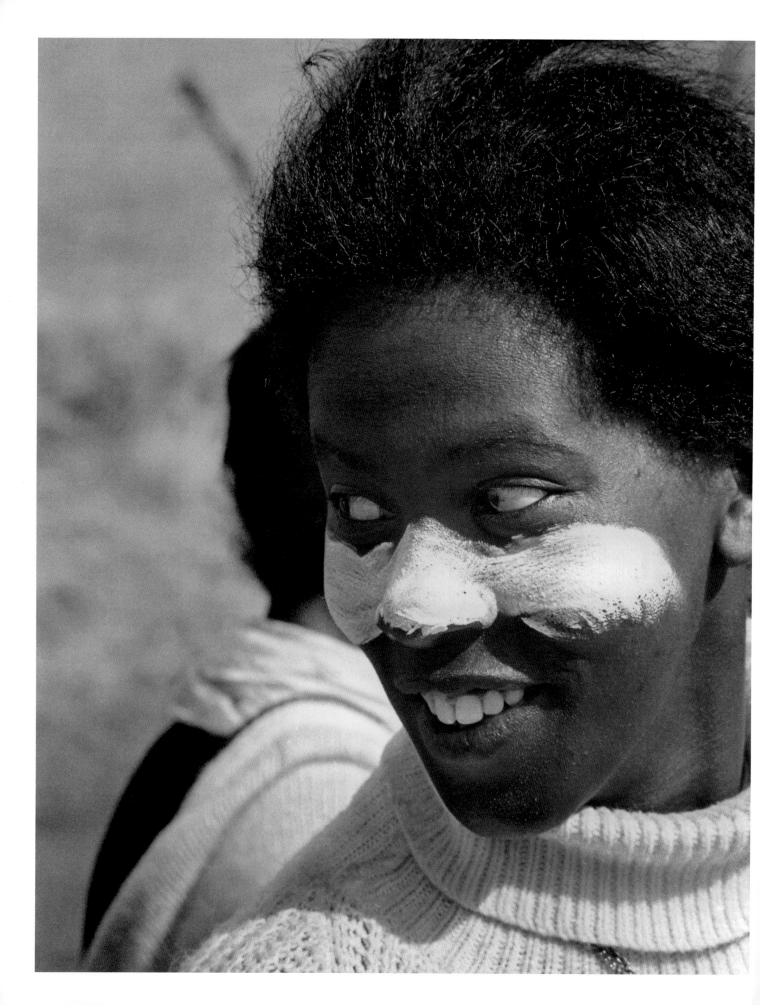

CONTENTS

INTRODUCTION: THE CASE FOR A NEW CANON

Photographers shot millions of pictures of the black civil rights struggle between the close of World War II and the early 1970s. Thousands of men and women with cameras working for mainstream media outlets, alternative newspapers, civil rights organizations, documentary history projects, police departments, and federal agencies, along with ordinary citizens, recorded the struggles of black Americans for social and economic justice. Yet, despite the staggering number of photographs shot and preserved, the civil rights story is represented today by a limited number of images that are remarkably similar.

When you picture the civil rights movement, which images come to mind? If you are among the more than 200 million Americans who have come of age since the 1960s, the odds are good that a predictable set of photographs helps you think about the movement. Among them are surely images from the South of fire hoses and attack dogs turned on peaceful protestors; well-dressed youths taunted, punched, and kicked at sit-ins at segregated lunch counters; Freedom Riders bombed and beaten while integrating interstate buses; black children harassed for attending previously all-white schools; voter-rights marchers clubbed and gassed by state troopers; and perhaps an image or two from the North or West of white antibusing violence or a Black Panther protest. In both the public imagination and our history books, the civil rights story is overwhelmingly one of well-behaved black protestors victimized by racist and violent whites.[1]

This observation hardly seems remarkable. A few famous photographs have for many years defined the popular story told about the civil rights struggle: dignified black protestors passively resisted the laws and social conventions of Southern white society and suffered, with stoicism, unwarranted attacks by white mobs and police. Since the early 1960s reporters and historians have credited the photographic evidence of such protests with helping to transform American society. From the moment of their publication in Northern newspapers and magazines, the photographs were lauded for affording fair-minded white citizens the opportunity to experience the plight of African Americans in the South, so fostering white sympathy for blacks and, ultimately, support for legislative reform, including the Civil Rights Act (1964) and the Voting Rights Act (1965).[2] Over the years that handful of famous civil rights photographs, which virtually all Americans can picture, have come to epitomize the struggle. But the role that the photographs played in this history is considerably more complex.

Scholars of U.S. history credit black activists with driving many of the social and legislative reforms of the civil rights era. Over time black protestors, politicians, and educators pushed white Americans to reassess their positions on race relations and social justice. Change was driven by black action, not victimhood.[3] Yet the best-known photographs do not show blacks defending themselves (never mind fighting back), and only infrequently do they illustrate African Americans delivering impassioned speeches, organizing voter-registration drives, running for office, educating younger generations, or advancing legislative reforms. Photographs exist of all these activities. They circulated during the civil rights era in black newspapers and magazines, left-leaning white publications, and, on occasion, in the mainstream press, but they were seen by only a small minority and never assumed a place in the American imagination as representative of the struggle.

What the best-known photographs illustrate is the "passive resistance" for which the civil rights movement is famous. There is considerable evidence that these iconic scenes of submissive black protestors taunted and brutalized by white public-safety officials and mobs moved many millions of white Americans to feel sympathy for blacks. But it is significant that the majority of civil rights organizations in the second half of the twentieth century shunned the "passive resistance" label, preferring to describe their approach with the decidedly active phrase: "nonviolent direct action."[4] For organizers and rank-and-file activists, sit-ins, marches, and rallies, as well as grassroots political organizing and voter-education drives, were active strategies that demonstrated black power and created the conditions for its expansion. "Passive resistance" no more sums up the reality of the civil rights struggle than do the famous photographs of black victims.

There is little doubt that the best-known photographs provide largely accurate depictions of events in the street. The point is that their relentless focus on confrontational protests, and specifically on white-on-black violence, promotes a distorted impression of the civil rights movement overall. When a tiny subset of a movement's visual history is elevated as representative of that movement, photographs that are individually truthful distort history as a group.

In restricting themselves to the publication of a particular type of photograph, white media outlets were not trying to mislead their readers or diminish the achievements of black activists. The mostly liberal reporters and editors who worked for mainstream media outlets in the North sympathized with citizens whose rights were systematically denied and sought to advance the cause of black civil rights. They were, however, conscious of the need to carefully nurture white public support for social and legislative change. At the time a political cross section of whites worried about the disorder fostered by black protests and the white counterprotests they sparked. Millions of whites, whether they supported or deplored black activism, were united in their fear that massive protests would fray the bonds of civil society, leading to domestic chaos and strife. In order to garner sympathy for black citizens and to build support for social and legislative changes that would make U.S. society more just, liberal white editors consistently published civil rights photographs that did two things well: offer stark, morally unambiguous narratives; and reassure whites that racial reform need not lead to social disorder—or even to upending the racial hierarchy that had long favored European Americans.[5]

Black activists organized to raise awareness and fight a diverse array of inequalities present in U.S. society. Some actions targeted segregation in public transportation, libraries, restaurants, housing, public recreational facilities, schools, and universities; others tackled discriminatory public or private hiring practices, loan policies, salary inequities, and job safety or fought state poll taxes, voter eligibility tests, police brutality, and mob violence. Yet despite the diversity of issues that individual actions sought to remedy, the famous photographs of the movement differentiate little between the various protests and give scant information on the specific battles fought. Famous photographs of civil rights protests, ranging from Anniston to Selma, are virtually interchangeable. All displayed similar scenes of white-on-black violence or its

threat, and each drew from the same menu of generalized narratives of black versus white, passive versus active, and good versus bad.[6]

The photographs' focus on white-on-black violence reassured whites that blacks needed their help. Because few of the iconic images capture the forceful actions of black organizers, protestors, and politicians, they implied that justice hinged on the intervention of concerned white citizens. Pictures of victimized activists raised the sympathy of whites at the same time that they made images of protest safe.[7] Since the depicted protestors appeared in no position to take power or force changes in U.S. society, the photographs helped tamp down white discomfort with black protest by suggesting that major reforms remained within the control of whites. According to the photographs published by the mainstream media, whites, and not blacks, held the power needed to set the pace and establish the extent of reform.

As we have begun to see, iconic photographs are not those that capture the essence of a particular event. The opposite is often true. In attaining iconic status, photographs frequently detach themselves from the events and era they purportedly depict; they rise above the specifics to tap into broader cultural narratives. My undergraduates, even when they have not previously seen them, can readily explain the meaning of the famous dog-attack photographs of Birmingham: good, submissive blacks do battle against bad, violent whites.[8] The photographs do not add to students' knowledge of the civil rights movement so much as they confirm simplistic narratives (unconnected to the Birmingham campaign) that they already know. The same is true when students compare civil rights photographs to other famous images of black-white conflict. My students see a clear line of descent running from nineteenth-century photographs of slaves abused by their masters to twenty-first century videos and stills of black civilians harmed by police. Separated by 150 years of history —and radically different racial and social systems—these disparate images of violence convey nothing historically specific about the events they purport to capture. My students' responses suggest that iconic photographs mirror back to us

powerful social narratives more than they provide faithful reports of, or insights into, particular events.

This catalogue proceeds from the basic assumption that photographs do not speak for themselves. Iconic photographs need explanation if they are to be understood in historical context and, moreover, if they are to mean more than the simplistic and supposedly timeless narratives to which they are attached. But the same is true of the so-called "forgotten" photographs introduced in this catalogue. They require explication: to be rooted in their time and place, of course, but also to make good on their potential to shed new light on the civil rights movement. Because forgotten photographs are often linked to more socially marginal narratives, they have the ability to expand the range of stories we tell about a given incident, person, or era.

Freedom Now! Forgotten Photographs of the Civil Rights Struggle makes the straightforward point that there are several equally legitimate ways of narrating the civil rights story that have long been ignored in mainstream society. To expand our understanding of the civil rights movement, and twentieth-century U.S. history, this exhibition offers alternative pictures of the era. It displays photographs showing well-known events from vantage points not commonly depicted in history books as well as those that illustrate lesser-known people and incidents that were nonetheless integral to the struggle. *Freedom Now!* puts into circulation a new set of photographs to offer a fuller account of the actions and aspirations of the activists themselves and to counterbalance our fixation with the famous photographs, which were often selected and reproduced based on their likely effects on whites. Together, these less famous and, on occasion, previously unknown photographs form a picture of black planning and action that challenges the stories told in many of the famous images. This exhibition seeks to focus twenty-first-century Americans on facets of the struggle that were of paramount importance to the protestors and the many millions of black citizens who observed the struggle with interest, even when they did not take to the streets themselves.[9]

This exhibition and catalogue are divided into seven sections: "The Canon," "Historical Precedents," "Doctored," "Strength," "Women," "Children and Youths," and "Joy." The first two sections provide a modest selection of the famous photographs to orient viewers and sharpen the points of divergence between the standard pictorial account of the civil rights movement and the alternative view presented by the forgotten photographs of the exhibition. In "The Canon" famous photographs of Little Rock, Montgomery, Birmingham, Jackson, and Selma are analyzed for the visual and narrative qualities they share; the people, events, and issues they failed to record; and the messages on race they communicated to period audiences. To augment the many discussions that accept without question the documentary qualities of these photographs, I step back from their narratives to also consider the political and social conditions that led these photographs to be selected from among the many hundreds or thousands taken of each event. My analysis takes care to recount the actions of participants, but instead of focusing solely on those figures captured within the tiny photographic frame, I broaden out the discussion to explore the motivations of photographers, editors, organizers, and activists.

The second, closely related section, "Historical Precedents," argues that the expectations for what canonical civil rights photographs should depict were conditioned by nineteenth-century standards for the representation of black slaves and freedmen. A selection of early photographic prints created by white abolitionists to raise sympathy and funds for blacks makes clear the narrative and formal correspondences between abolitionist and civil rights photography. The images of ex-slaves depict anonymous, nonthreatening subjects whose bodies bear the marks of abuse at the hands of former masters. While many of the freedmen showed great resourcefulness in making their escape from Southern plantations, the images reference suffering, not ingenuity. So ingrained was this model for the representation of blacks that it readily suggested itself to twentieth-century photographers in search of a formula for the sympathetic and safe depiction of black protestors. These images suggest why journalists arrived at scenes of protest with a preexisting picture of what

the "right" or "best" photograph should look like. Instead of simply finding compelling shots of activism, photographers unconsciously sought out particular scenes and framed them in predetermined ways to meet social expectations for how blacks and whites "should" look. This section also illustrates how the seeds for more progressive manners of representing black identity and action were sown in the wake of emancipation, when blacks enjoyed greater resources to represent themselves.

"Doctored" illustrates how civil rights photographs were physically and contextually manipulated. When digital alterations of newspaper or magazine photographs come to light today, they invariably lead to vigorous public debate on the responsibilities of the press to provide unadulterated pictures of reality. In the middle of the last century, however, media standards were much looser and the public more trusting; even altered images were deemed capable of capturing the essence of an issue or event. This section demonstrates the lengths to which photographers and editors went to secure civil rights images that communicated expected narratives. Examples show mainstream editors using extensive airbrushing and radical cropping, pairing images with misleading captions, and publishing photographs taken wholly out of context to make the required points.

The next four sections offer new kinds of photographs for reimagining the civil rights struggle. To come to terms with the photographic legacy of the movement, we must both analyze the limitations inherent in the canon and develop new, more inclusive ways of remembering the past. "Strength" tackles head-on the myth that black Americans assumed submissive roles within the civil rights struggle. It begins with a grainy photograph taken surreptitiously during the Mississippi trial of the two men who murdered fourteen-year-old Emmett Till in the summer of 1955. The photograph shows Till's great uncle rising from the witness stand and pointing out for the court the men who abducted the boy in the middle of the night. The uncle's act of bravery stunned Mississippi whites and galvanized blacks across the United States, but it received comparatively little attention in the white press. Mainstream reporters showed greater interest in discussing

the novelty of trying whites for the murder of an African American in the South, and in wringing their hands over the gruesomeness of the crime, than in explaining to readers the unprecedented decision taken by Till's relatives to confront the killers in open court.

Other photographs in "Strength" that are little known today depict blacks arming themselves and fighting back against rioting police, registering to vote in hostile county courthouses controlled by unsympathetic Southern whites, providing armed defense of black-run institutions from domestic terrorists, and exercising the right to vote. This section includes a news photograph capturing the infamous "Black Power" protest of John Carlos and Tommie Smith at the Mexico City Olympics in 1968. While the image is not traditionally seen as representing the civil rights era, this silent and peaceful protest was intimately connected to the politics and techniques of the movement. Its apparent distance from traditional civil rights imagery has much more to do with the unambiguous power the men exhibited than with their complaints against the United States.

"Women" and "Children and Youths" each address an imbalance in the photographic record of the civil rights movement. Activists and historians know that women and young people appear in surprisingly few of the famous images of the civil rights struggle given the key roles they played in advancing the cause. "Women" includes a photograph of the domestic workers who in 1955 and 1956 refused to ride the buses in Montgomery, choosing instead to trudge to and from work on foot in the heat and rain. More than any single leader, it was these thousands of unheralded women who launched the modern civil rights movement and propelled Dr. Martin Luther King Jr. to national prominence. Other photographs capture women registering to vote in South Carolina and Louisiana and physically resisting armed policemen in Alabama. This section highlights the particular contributions of a number of singular female organizers, including Fannie Lou Hamer and Ella Baker, both of the Mississippi Freedom Democratic Party, and a sampling of little-known women who served bravely as midwives, teachers, and political organizers.

Similarly, "Children and Youths" documents the dedication of and sacrifices made by black children who volunteered to integrate schools in the South and North. These photographs remind viewers of the central place children occupied in debates over civil rights and of the many protest actions that took place in the North. Other photographs in this section show college students staging sit-ins at department-store lunch counters that incited no violence and six- and seven-year-olds facing arrest in Birmingham, Jackson, and Selma for participating in civil rights protests.

The final section, "Joy," impresses upon readers that the civil rights movement brought great happiness to millions of black Americans. Not only did black activists and observers take satisfaction in the gains achieved by the struggle, but they also relished the sense of power and solidarity that working together for greater freedoms brought. While canonical images of the movement illustrate stoic, often grim, protestors confronting brutality, thousands of counterexamples illustrate the pleasure blacks took in movement activism. This section displays photographs of activists joined in joyful prayer and song, reacting with smiles to speeches and civil rights marchers, proudly displaying "certificates of courage" and voter-registration cards, and even laughing and singing while led to fetid municipal and county jails. Many black activists saw the act of binding themselves into a community to fight discrimination as not only an effective means for creating a more just society but also a worthy end in itself.

The photographs in these final four sections of the catalogue—"Strength," "Women," "Children and Youths," and "Joy"—expose viewers to alternative histories and perspectives preserved in forgotten photographs and so increase understanding of the roles black Americans played in reforming American society. At the same time they illustrate the high stakes involved in selecting groups of images with which to narrate our nation's history. There are risks in circulating both canonical and forgotten photographs on civil rights. It is simply not possible for several dozen images—no matter how carefully selected—to communicate the complexity of a movement that involved millions of people from across the

country working within hundreds of distinct organizations toward many different political and social goals over several decades. To gather a group of photographs for display from among the multitude produced is necessarily to advance a particular perspective.

While all collections of photos present a partial and subjective picture of their subjects, they are not all equally flawed. Recall that the civil rights canon with which we are all familiar was not formed with forethought. It grew up organically over time in response to the unarticulated fears and desires of the people who guided the mainstream media (most of whom were white). In contrast, the counternarrative presented in this catalogue was deliberately created as a historical corrective. The photographs here do not so much replace as augment the picture presented in the famous images, ensuring that a wider sampling of black American perspectives receives equal time.

To be eligible for inclusion in this catalogue, photographs had to meet two important tests. First, they had to present a picture of blacks as effective agents in driving the reforms of civil rights, regardless of who—freelancers or staff photographers, men or women, blacks or whites—shot the images. And second, they had to be readily available to the mainstream media outlets of their day. I restricted my selection to photographs that were then accessible to the mainstream press because I aimed to tell a story of black activism that was available to white reporters and their editors in the 1960s and 1970s. While commercial photographers took many of the photographs included here, movement activists and supporters, concerned to make their work available to wider audiences, shot others. The picture of black activism presented herein is one that mainstream newspapers and magazines could have told had they been so inclined.

A good number of the photographs included in this catalogue never made their way into twentieth-century newspapers and magazines. They were among the millions of photographs that editors passed over for aesthetic, narrative, or political reasons before filing them away. Many of these overlooked photographs are reproduced here because they highlight a

forgotten incident, individual, or issue whose consideration enriches the understanding of the civil rights movement. They are necessarily not photographs that played a part in shaping U.S. society, and several of them fail to meet aesthetic standards for "good" photography. But wherever possible I selected photographs with more obvious social roles and aesthetic appeal. Many of the chosen photographs have revealing publication histories—those reproduced in both the white and black press but interpreted in different ways by each; those published either in the mainstream media or black press but ignored by the other; or those widely published photographs whose crystal-clear narratives distracted readers from considering the underlying economic, social, or political dynamics of the scene.

This catalogue ultimately tells a story about the power of photographs to both explain and create our history. And it initiates a longer conversation on how and why particular people, events, and issues have been edited out of the photographic story we tell about our past.

NOTES

1 For the standard account of the civil rights movement, see Taylor Branch, *Parting the Waters: America in the King Years, 1954–63* (New York: Simon & Schuster, 1988); William A. Nunnelley, *Bull Connor* (Tuscaloosa: University of Alabama Press, 1991); Diane McWhorter, *Carry Me Home: Birmingham, Alabama, and the Climactic Battle of the Civil Rights Revolution* (New York: Simon & Schuster, 2001); David Chalmers, *Backfire: How the Ku Klux Klan Helped the Civil Rights Movement* (New York: Rowman & Littlefield, 2003); and Gene Robert and Hank Klibanoff, *The Race Beat: The Press, the Civil Rights Struggle, and the Awakening of a Nation* (New York: Alfred A. Knopf, 2007).

2 For the purported power of civil rights photographs to transform American society, see Vicki Goldberg, *The Power of Photography: How Photographs Changed Our Lives* (New York: Abbeville Publishing Group, 1993), 204; Taylor Branch, *Pillar of Fire: America in the King Years, 1963–65* (New York: Simon & Schuster, 1998), xiii, 77; Steven Kasher, *The Civil Rights Movement: A Photographic History, 1954–68* (New York: Abbeville Press, 2000), 96; and Michael Durham, *Powerful Days: The Civil Rights Photography of Charles Moore* (Tuscaloosa: University of Alabama Press, 2002), 90.

3 David J. Garrow, *Protest at Selma: Martin Luther King, Jr., and the Voting Rights Act of 1965* (New Haven, CT: Yale University Press, 1978); Adam Fairclough, *To Redeem the Soul of America: The Southern Christian Leadership Conference and Martin Luther King, Jr.* (Athens: University of Georgia Press, 1987); Charles M. Payne, *I've Got the Light of Freedom: The Organizing Tradition and the Mississippi Freedom Struggle* (Berkeley and Los Angeles: University of California Press, 1995); J. Mills Thornton III, *Dividing Lines: Municipal Politics and the Struggle for Civil Rights in Montgomery, Birmingham, and Selma* (Tuscaloosa: University of Alabama Press, 2002); Erina Duganne, *The Self in Black and White: Race and Subjectivity in Postwar American Photography* (Hanover, NH: Dartmouth College Press, 2010); Leigh Raiford, *Imprisoned in a Luminous Glare: Photography and the African American Freedom Struggle* (Chapel Hill: University of North Carolina Press, 2011).

4 Howell Raines, *My Soul Is Rested: Movement Days in the Deep South Remembered* (New York: G. P. Putnam's Sons, 1977), 28; David J. Garrow, *Bearing the Cross: Martin Luther King, Jr., and the Southern Christian Leadership Conference* (New York: Quill, 1986), 32, 99; and Flip Schulke, ed., *Martin Luther King, Jr.: A Documentary . . . Montgomery to Memphis* (New York: W. W. Norton & Company, 1976), 117.

5 Many of the basic assertions in this introduction on the social function of civil rights photography for white Americans were developed in Martin A. Berger, *Seeing through Race: A Reinterpretation of Civil Rights Photography* (Berkeley and Los Angeles: University of California Press, 2011); for whites' expectations of civil rights photography, see 39, 46–52.

6 Henry Hampton and Steve Fayer, eds., *Voices of Freedom: An Oral History of the Civil Rights Movement from the 1950s through the 1980s* (New York: Bantam Books, 1990), 457; Berger, *Seeing through Race,* 19–22.

7 Berger, *Seeing through Race,* 23–32.

8 My anecdotal impressions on how college students respond to civil rights photography are confirmed by the results of a survey of undergraduates that illustrate their tendency to project dominant and simplistic cultural narratives onto such photographs. For the study's design, results, and social implications, see Margaret Ann Spratt, "When Police Dogs Attacked: Iconic News Photographs and the Construction of History, Mythology, and Political Discourse," (PhD diss., University of Washington, 2002).

9 Since my aim is to provide alternative historical contexts within which to understand both the famous and forgotten photographs of the civil rights struggle, it bears noting that my revisionist project also has a history. As early as 1900 the African American sociologist, historian, and activist W. E. B. du Bois staged an exhibition of photographs for the American Negro Exhibit at the Paris Exposition. Du Bois offered 363 photographs of black Americans, illustrating a multifaceted picture of black life in the South and so providing a strong foil to the often racist and always one-dimensional manner in which photographic depictions of blacks then circulated in white culture. For an insightful analysis of Du Bois's project, see Shawn Michelle Smith, *Photography on the Color Line: W. E. B. du Bois, Race, and Visual Culture* (Durham: Duke University Press, 2004).

THE PHOTOGRAPHS

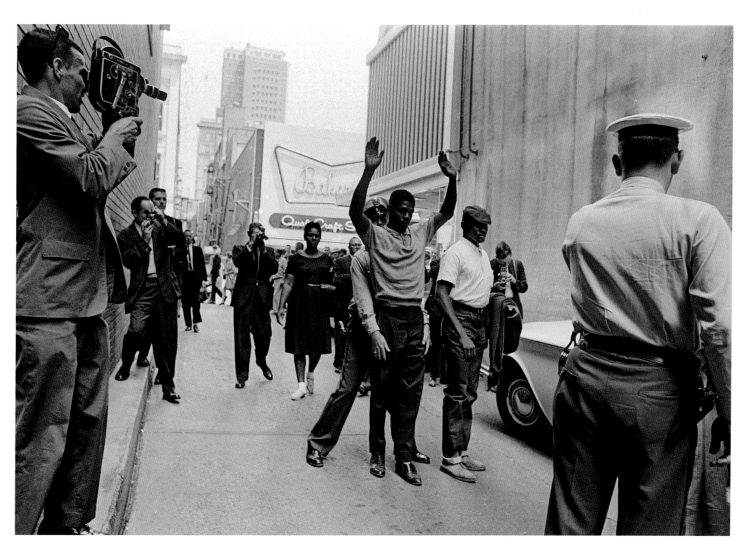

1

1. Unidentified photographer, *Police Officer Frisks Demonstrator While Newsmen Record Event*, Birmingham, Alabama, April 15, 1963. AP Images.

Still and moving pictures were central to the strategies of civil rights organizers. So important were photographs to movement leaders that they cultivated relationships with and granted access to mainstream press photographers. Some civil rights organizations went so far as to expend precious resources employing photographers on their staffs. Black activists knew that they did not wield sufficient power to peacefully change U.S. society on their own. Change was contingent on attracting white allies to the cause. Photographs offered one of the most powerful and immediate means of reaching whites.

Photographs did two things well: They provided whites living in segregated communities with a clear picture of the day-to-day indignities, violence, and activism that characterized the lives of American blacks, and they put a human face on often abstract campaigns for social justice. While it was possible for whites to better understand the fight against segregation or black disenfranchisement by reading unillustrated newspaper and magazine articles, the addition of photographs helped make the injustices glaring. And when it came to conveying to a national audience what was at stake in calls for fair hiring, housing justice, or economic opportunities, photographs made these more abstract concepts concrete.

This photograph of an unidentified civil rights activist arrested during a protest in Birmingham, Alabama, is unusual in that it shows not just the arrest but also the scrum of still- and moving-picture cameramen huddled around the action. It captures both an event and the manner in which it was recorded—and it provides a visual analog for the way in which I analyze the photographs in this catalogue. My goal is to pull back the camera and explore not simply the scene of protest but the contexts in which it was transformed into photographs.

Photographs are not straightforward slices of reality. They are subjective pictures, created by men and women with particular outlooks and agendas and circulated in newspapers and magazines that were similarly interested in communicating particular messages to their audiences. This catalogue understands photographs to be created by complex social forces. It considers not only what they depict but also what they leave out, and why we do—or do not—accept them as being representative of our history.

THE CANON

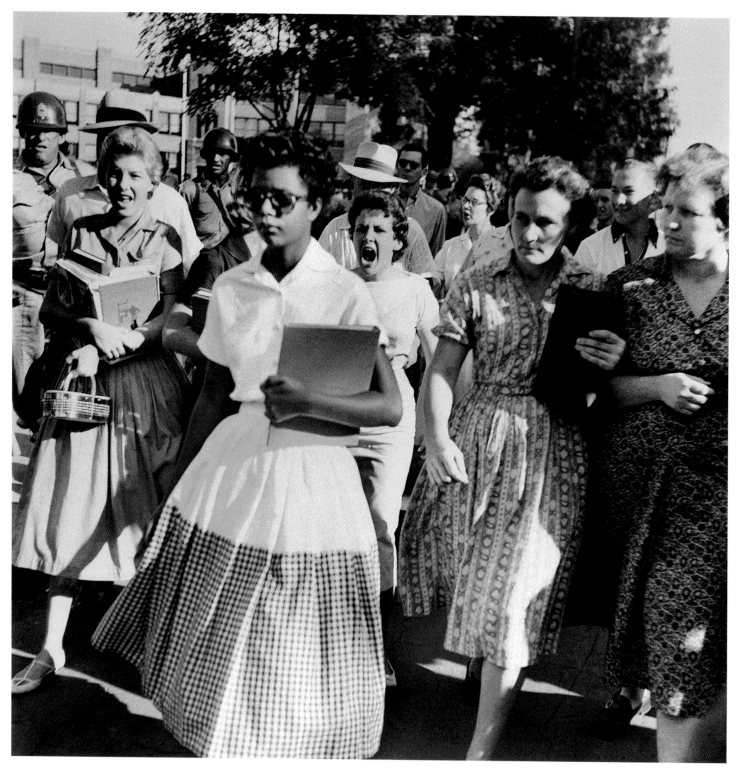

2

2. Pete Harris, *Elizabeth Eckford, One of the Little Rock Nine, Pursued by the Mob outside Little Rock Central High School,* Little Rock, Arkansas, September 4, 1957. © Bettmann/Corbis.

In response to the 1954 Supreme Court decision in *Brown v. Board of Education,* which found separate public schools for blacks and whites to be unconstitutional, the school board in Little Rock, Arkansas, approved a plan in 1955 to begin the gradual integration of city schools starting in the fall of 1957.

On September 4, 1957, the first cohort of nine black students assigned to begin the long-awaited integration of the city's high schools made their way to Little Rock High School. Fifteen-year-old Elizabeth Eckford dutifully climbed the stairs to the front doors of her new school alone, having been accidentally separated from her eight black classmates. There she was brusquely turned away by armed National Guard troops acting on orders from Governor Orval Faubus, who had pledged to defy the school board and the Supreme Court in his efforts to defend segregation.

This photograph captures Eckford, appearing calm and composed, as she retraces her way to the street, surrounded by a threatening crowd of classmates and facing shouts of "Lynch the nigger!" In the background we glimpse National Guard troops, who do nothing to defend the young girl. The photograph is the most famous of the many taken that day in Little Rock, and it has come to stand as a symbol of the school integration battles. While the photograph presents a real-life incident, its formulaic depiction of blacks victimized by whites hinders more complete understandings of the events surrounding school integration and the broader civil rights movement. It tells us nothing about the century-old struggle of black parents for better schools for their children, the patient legal challenges levied against segregated schooling by lawyers employed by the National Association for the Advancement of Colored People (NAACP), the excitement of black students at the prospect of gaining access to better schools, or even the responses of those progressive white parents and students who supported the Supreme Court ruling and school board's plan for integration. It condenses these struggles instead into an image of a lone black girl's suffering and stoicism in the face of an ugly white crowd. And it ultimately made it too easy for the millions of white Americans who saw Eckford's image in the newspapers to imagine that race was primarily an interpersonal problem—here, of racist white schoolgirls—and to ignore its rootedness in laws, practices, and institutions that were considerably harder to address.

3. Joseph Postiglione, *Firebombed Freedom Riders' Bus outside Anniston, Alabama,* May 14, 1961. © Bettmann/Corbis.

The Freedom Riders were an integrated group of black and white activists committed to nonviolent civil disobedience who traveled together on interstate buses through the South in the early 1960s. Their goal was to draw national attention to the lack of enforcement of federal court decisions and Interstate Commerce Commission rulings prohibiting the maintenance of segregationist ordinances in restaurants, waiting rooms, and restrooms in terminals serving interstate travel. They hoped to publicize the extent to which communities in the South, with the acquiescence of national transportation companies, flouted established federal laws in their determination to maintain unconstitutional bans on integration.

Inspired by similar bus rides organized in the 1940s by an earlier generation of activists, young members of the Congress of Racial Equality (CORE) and the Student Nonviolent Coordinating Council (SNCC) boarded a Trailways and a Greyhound bus in Washington, DC, for the first Freedom Ride in May 1961. Their plan was to sit together on integrated buses all the way to Louisiana, but on this first trip the Riders were forced to abandon their buses in the face of significant violence in Alabama. The public safety commissioner in Birmingham colluded with local members of the Ku Klux Klan to attack both buses and end their journeys.

Six Klansmen boarded the Trailways bus during a scheduled stop in Anniston. Once aboard they forced the black Riders to the back of the bus while beating white and black Riders

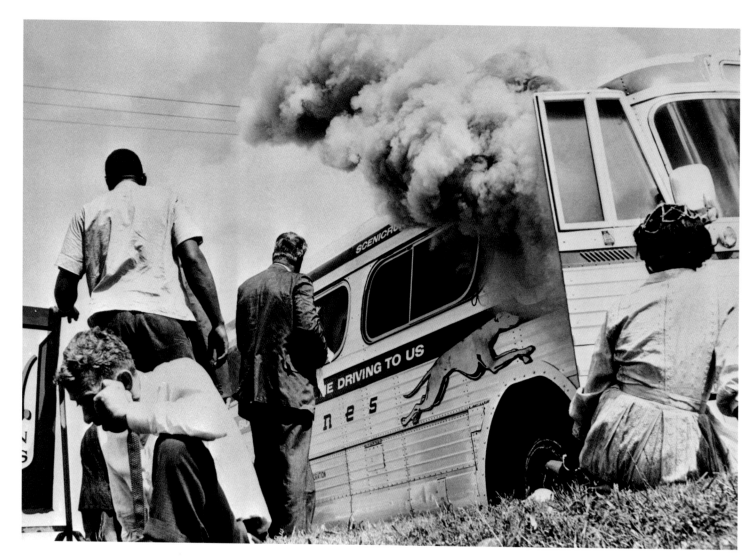

alike. They then ordered the driver to proceed to Birmingham, where the bus was met by dozens of men armed with pipes. As per the Klansmen's arrangement with the public safety commissioner, there were no policemen in sight. Forced off the bus, the Freedom Riders were savagely beaten.

The Greyhound bus was met by an even larger mob when it arrived in Anniston. The men of the mob openly carried guns, blackjacks, chains, and clubs. Seeing that it would be too dangerous to stop and test the integration of the terminal's facilities, the Riders asked the driver to continue on to Birmingham. When the waiting mob realized that the bus passengers would not descend, they slashed at the bus's tires. The driver managed to maneuver the bus to the outskirts of Anniston before his tires deflated and he was forced to pull to the side of the highway. There, Klansmen who had followed from the Anniston station surrounded the bus and proceeded to hold the door shut, break a window, and throw in a firebomb. In time the door was released, and the Riders escaped the fire.

This photograph was taken after the bus was set ablaze and the rioters retreated. Shot from a gulley at the side of the highway, the photograph shows dazed and wounded Freedom Riders in the foreground from below and the burning Greyhound bus looming large behind them. This image brought significant public attention to the issue of interstate travel and greatly embarrassed the administration of President John F. Kennedy. But its focus on the aftermath of violence neglected equally valid narratives on the bravery and idealism of the Freedom Riders, their commitment to nonviolence, their deeply held beliefs in racial coexistence, and the day-to-day indignities experienced by black riders on public buses in the South. Once again, the photograph captured an actual event, but its focus on violent whites and abused blacks (and their white allies) limited the stories told about the complex motivations and strategies of the men and women involved.

4. **Charles Moore, *Firemen Use High-Pressure Hoses against Protestors*, Birmingham, Alabama, May 3, 1963. © Charles Moore/Black Star.**

This photograph and the one that follows—of fire hoses and dogs loosed against antisegregationist protestors in Birmingham, Alabama—are among the best-known images of the civil rights struggle. Both were shot by the Southern freelance photographer Charles Moore and first published in an extensive photo-essay in *Life* magazine in May 1963.[1]

In April 1963 the Southern Christian Leadership Conference (SCLC), a national civil rights group led by Dr. Martin Luther King Jr., launched a long-planned protest campaign in Birmingham, Alabama, with the strong support of local black activists. King and his allies sought to draw national attention to their six modest demands of Birmingham authorities: desegregate local stores, encourage local merchants to adopt fair hiring practices, dismiss charges against protestors from prior demonstrations, provide equal employment opportunities for blacks within city government, reopen and desegregate municipal recreation facilities, and establish a biracial committee to further desegregate the city.

King was keenly aware that the success of the campaign would hinge on attracting white supporters who could bring pressure to bear on Birmingham's elected officials and local business owners. He also knew that Northern media outlets were more likely to cover the civil rights movement—and get his message out to a large national audience—when the stories were dramatic. In bringing his protest to Birmingham, King counted on the penchant of the city's racist, violent, and publicity-seeking public safety commissioner, Eugene "Bull" Connor, to create newsworthy spectacles.

After a month in which hundreds of black activists were quietly carted off to jail for marching on city hall or holding prayer vigils in the street, Connor grew frustrated at his inability to quell the protests. In early May he opted for more forceful tactics, ordering the firemen and police under his command to turn high-pressure fire hoses and dogs against

the protestors. The ensuing images provided, in the words of
one reporter, the most "gripping" images of the civil rights
struggle to date.[2] Moore's photographs of hose-wielding
firemen are the best known of those taken in Birmingham,
though they differ from those shot by his colleagues only
in degrees. Virtually all the photographs preserve the same
visual structure: firemen occupy the foreground space as they
direct their hoses toward black protestors in the distance. As I
will discuss in greater detail in my analysis of how this photo-
graph was framed when published by *Life* magazine (number
18), this structure consistently aligned viewers with the white
firemen, since the scene is captured from their vantage point.

While contemporary viewers likely see in these images the
bravery and dedication of protestors willing to stand against
the force of the hoses, mainstream media outlets in the
1960s saw the black protestors as the hapless victims of vio-
lent whites. They reported on youths hit with firemen's hoses
as "flattened," "sent sprawling," "spun . . . head over heels,"
"sitting passively," "swept along the gutter by a stream of
water," "cut . . . down like tenpins," or "flung . . . into the air
like sodden dolls," some with their clothing "ripped off."[3]
Moore's photograph of firemen and protestors spoke clearly to
whites in the North of the suffering of blacks. Such photo-
graphs ensured that fire hoses and dogs would be etched into
the American imagination as the essence of the Birmingham
campaign, leaving few aside from the participants to recall
the six demands for which the activists struggled.

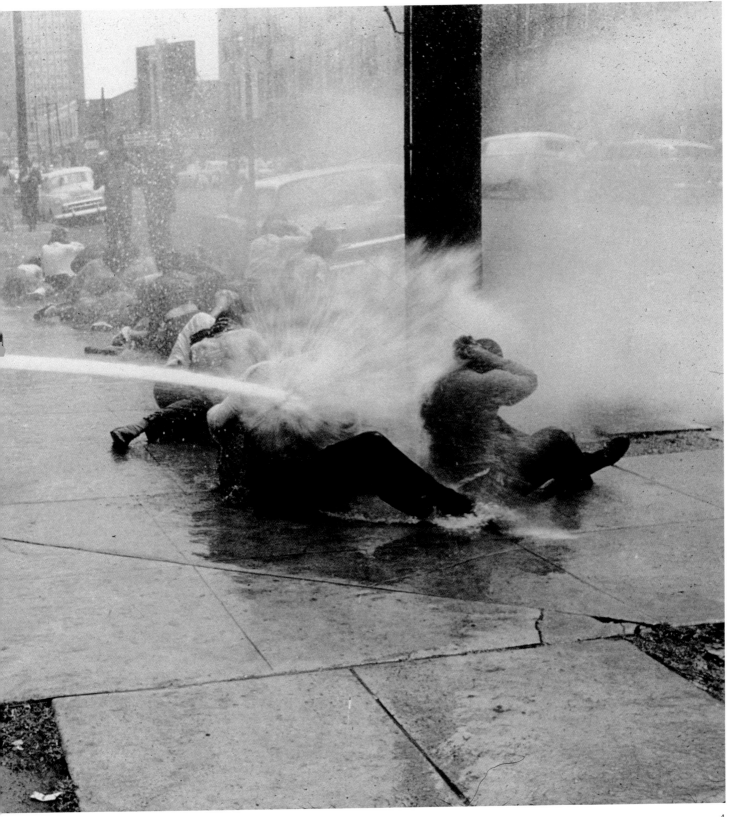

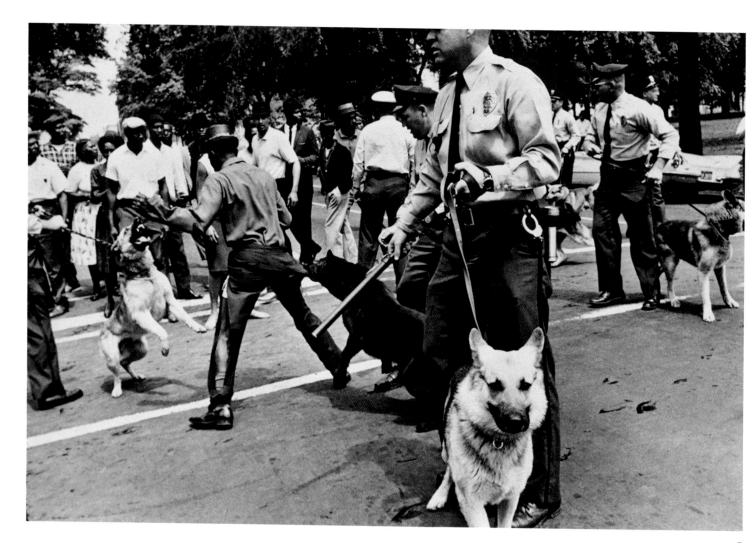

5

5. Charles Moore, *Police Dog Attack*, Birmingham, Alabama, May 3, 1963. © Charles Moore/Black Star.

The well-dressed black man at the center of this photograph is isolated from the spectators lining the far side of the street by a cluster of policemen and their dogs. The lunging and biting dog (right) and torn pant leg (left) testify to his treatment at the hands of the Birmingham police. Photographs of attacking dogs drew even more national—and international—attention than images of protestors hit with firemen's hoses. Seeing animals turned loose on human beings stirred a primal fear in many Americans, but it was a fear heavily conditioned by one's racial and ethnic identification. Blacks had stronger reactions than whites, sensing that such scenes depicted a more personal, immediate threat. African Americans linked the images to historical precedents in ways distinct from the majority of their white compatriots.

Many more black than white reporters and observers wrote of the ominous parallels between the use of German shepherd dogs against blacks in Alabama and Jews in Nazi Germany. In the aftermath of the publication of the dog-attack photographs, an irate Chicago resident wrote to the editor of the black-owned *Chicago Daily Defender,* claiming: "Adolph Hitler let loose many evils in this world. Not the least among them were snarling dogs trained to tear human flesh. With fiendish glee, the police and other constituted authorities in Birmingham, Ala., have adopted this tortuous method as a deterrent to black Americans." Other black observers referred to the use of dogs in Birmingham as "Nazi-like brutality" and "Gestapo tactics," with one even seeing the Birmingham campaign as "reminiscent of the Warsaw ghetto uprising in Poland."[4]

Bull Connor deployed German shepherds less than a generation after World War II, at a time when memories of the conflict remained strong. Millions of Americans had fought in the war, suffered its privations on the home front, or survived its destruction before immigrating to the United States. And yet it was mostly black (and a few Jewish) Americans who articulated a link between Alabama police and Nazi troops. Whites did not see the parallels as readily, either because they

reflected too poorly on U.S. society for them to be acknowledged or because they saw Connor as a figure on the political fringe. In contrast, the black experience of racism in U.S. society led many to regard Connor's attitudes and actions as mainstream. James Baldwin provocatively explained this to his white readers in *The Fire Next Time* (1963): "White people were, and are, astounded by the holocaust in Germany.... But I very much doubt whether black people were astounded—at least, in the same way.... I could not but feel, in those sorrowful years, that this human indifference, concerning which I knew so much already, would be my portion on the day that the United States decided to murder its Negroes systematically instead of little by little and catch-as-catch-can."[5] Even though blacks and liberal whites appeared united in their disgust for Connor's tactics, they experienced Moore's graphic photographs of violence in decidedly different ways.

6. Fred Blackwell, *Sit-In at F. W. Woolworth's Lunch Counter, Jackson, Mississippi*, May 28, 1963. © Bettmann/Corbis.

On February 1, 1960, four black undergraduates in Greensboro, North Carolina, took seats at a downtown Woolworth's lunch counter restricted to whites and asked for service. They were not served. But their protest struck a nerve with Americans, and news of their protest quickly spread around the country, sparking a new wave of sit-ins throughout the South and reinvigorating the modern civil rights movement. While lunch counter sit-ins were conducted against department stores of all sizes, they drew more press attention when staged against large national chains headquartered in the North. Northerners found it jarring to read about and see the enforcement of segregationist rules unimaginable at their local Woolworth's, Kresge's, Kress, and Rexall stores.

This photograph shows a lunch counter with three seated protestors. Clustered behind the activists is a large crowd—its front row occupied by boys of high school age in T-shirts, with a few older men in shirts and ties. Three undergraduates from the historically black institution Tougaloo College

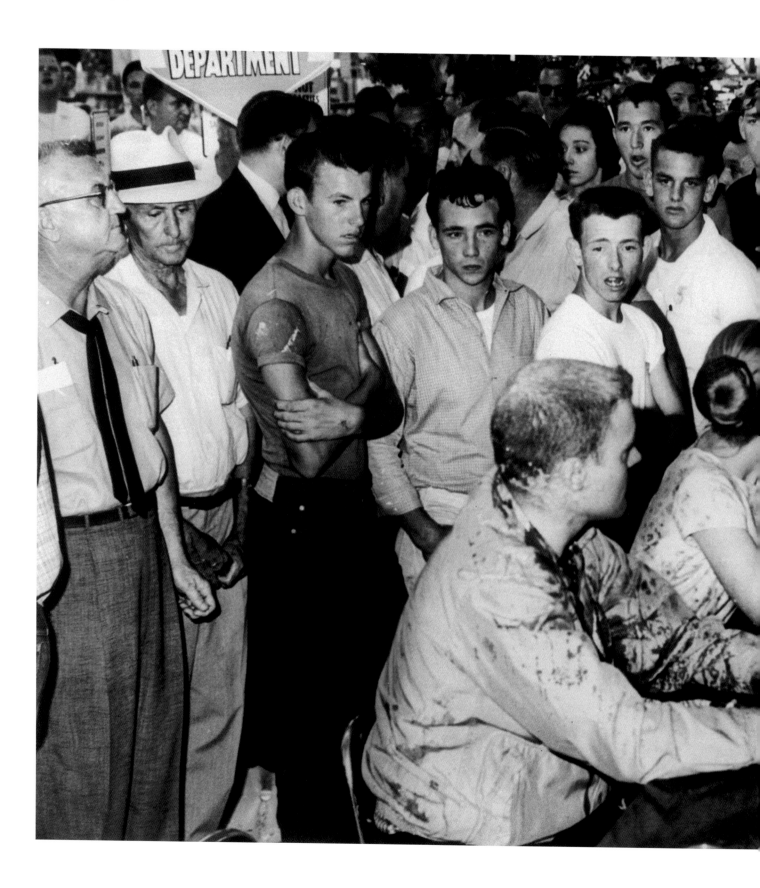

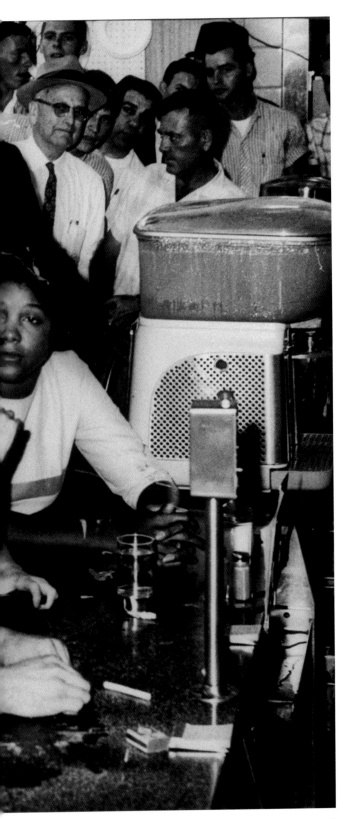

initiated the sit-in pictured here at a Woolworth's in Jackson, Mississippi. Tougaloo faculty and local high school students soon joined them. A waitress informed the students that they would not be served and suggested that they try ordering at the back counter. When it became clear that the protestors were intent on remaining at the white counter, the waitresses turned off the lights and retreated to the back of the store. Realizing that a sit-in was taking place, the few white customers already seated began to drift away from the counter. Within minutes, newsmen and photographers arrived to cover the sit-in. They surrounded the protestors and peppered them with questions: Where are you from? Why did you sit in? What organization sponsored it?

Just as the reporters were losing interest, a group of white high school boys poured into the store on their lunch hour. The boys surrounded and taunted the protestors. Two boys coiled rope into a noose and threatened to place it around the necks of the activists. In time the protestors were smeared with condiments from the counter, one was hit with brass knuckles, and all of them were pulled from their stools, hit, and viciously kicked once they fell to the floor. Each time a protestor was pulled off a stool, he or she would try to climb back on and weather the abuse nonviolently. After three hours of confrontation the store manager declared the store closed. Police, who had observed the sit-in from a distance and permitted the violence to go on, ultimately consented to protect the sit-in participants as they left the store.

The photographs selected and news articles written to chronicle the sit-ins in Jackson included comparatively little explanation of the "what," "why," and "where" that reporters asked about when they first arrived at the scene. As with most of the well-known images of sit-ins published in the press, the activists sit mutely, covered in food, which offered evidence of the actions of the mob. Of far more interest to news editors and their white readers than pictures of (or interviews with) activists explaining themselves were images that communicated the threat of white violence and its aftermath.

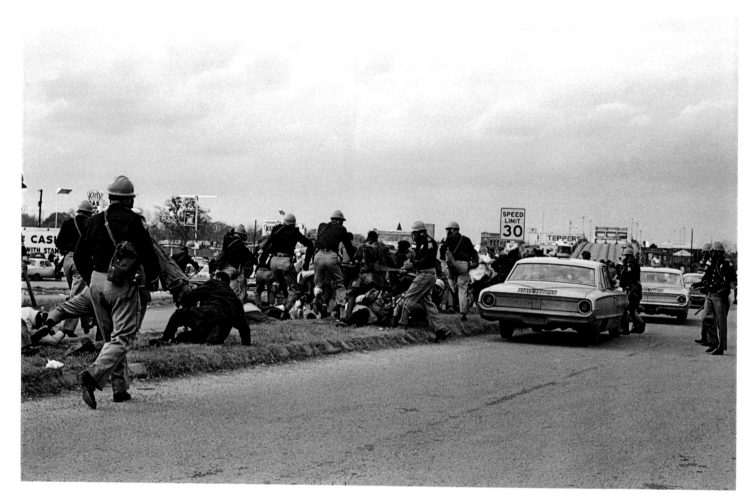

7

7. Spider Martin, *State Troopers Break Up Civil Rights Voting March in Selma, Alabama,* March 7, 1965. © Spider Martin.

In the spring of 1965 local activists in Selma, Alabama, working with organizers from national civil rights organizations, set off on a march to Montgomery to protest police violence and a lack of black voting rights in Dallas County, Alabama. The march began at Selma's Brown Chapel on Sunday, March 7, 1965, with 600 protestors setting out for Montgomery, led by the activists Hosea Williams and John Lewis. Just six blocks into the journey, as the marchers crossed the Edmund Pettus Bridge, they confronted a solid line of helmeted and armed Alabama state troopers, Dallas County sheriffs, and mounted civilian "possemen" blocking the four-lane road. As Lewis and Williams brought their columns to a halt some fifty feet from the line, the officer in charge, Major John Cloud, declared the protest march an "unlawful assembly" and demanded that the participants disperse.

Not wishing to provoke law-enforcement officers by advancing but determined not to retreat, Lewis encouraged the marchers behind him to kneel in prayer. As word of the prayer action passed through the columns of marchers, Cloud ordered his men to advance on horseback and foot. Firing tear gas and wielding billy clubs and bullwhips, they drove the protestors back over the bridge to their church and homes, as newspaper and television cameras recorded the mayhem. Lewis recalled "how vivid the sounds were as the troopers rushed toward us—the clunk of the troopers' heavy boots, the whoops of rebel yells from the white onlookers, the clip-clop of horses' hooves hitting the hard asphalt of the highway, the voice of a woman shouting, 'Get 'em! *Get* the niggers!'"[6] Between ninety and a hundred marchers were injured; more than fifty sought treatment at a local hospital, into which seventeen were admitted. One nearly died. That evening television stations interrupted their programming to show news footage of the clash; the next day, photographs of "Bloody Sunday" appeared in newspapers across the country.

The day after the rampage, versions of this photograph were prominently displayed in newspapers across the North. Most newspapers enlarged and cropped the photograph to focus readers' attention on the figure of Lewis (center), in his distinctive tan trench coat, with arm upstretched, trying to ward off the blows of a trooper's baton as protestors run and fall behind him. Months of intensive planning, legal maneuvering, and community organizing in support of a march dedicated to voting rights was reduced overnight to the image of a black man clubbed to the ground in a haze of tear gas.

8. Jack Thornell, *James Meredith Shot and Wounded during His March against Fear, Hernando, Mississippi,* June 6, 1966. AP/Wide World Photos and Jack Thornell.

On September 30, 1962, James Meredith became the first black student to enroll in the University of Mississippi in its 117-year history, despite the vigorous resistance of university officials, state politicians, and many local whites. Meredith's registration came at the conclusion of a dramatic process that included the initial rejection of his transfer application by the admissions office based solely on his race, an NAACP lawsuit filed on his behalf in U.S. District Court, a Supreme Court ruling in his favor, Justice Department involvement to enforce the court's ruling, a two-thousand-person riot on the campus against Meredith and the deputy federal marshals sent to protect him, and finally, the intervention of federal troops ordered to campus by President Kennedy. Long before Meredith graduated from Ole Miss in 1963, he was a nationally known figure.

Three years after his graduation, Meredith set out on a 200-mile March against Fear, from Memphis, Tennessee, to Jackson, Mississippi. His stated aim was to encourage voter registration among Mississippi blacks, who had the lowest registration rates in the country despite passage of the Voting Rights Act in 1965. Meredith did not seek the backing of leading civil rights organizations or build public support for his protest. When he began his trek just four supporters accompanied him. As a result, the march received little notice in the black press and virtually none in the mainstream media. On the second day of the march, however, the March against Fear became national news when a white would-be

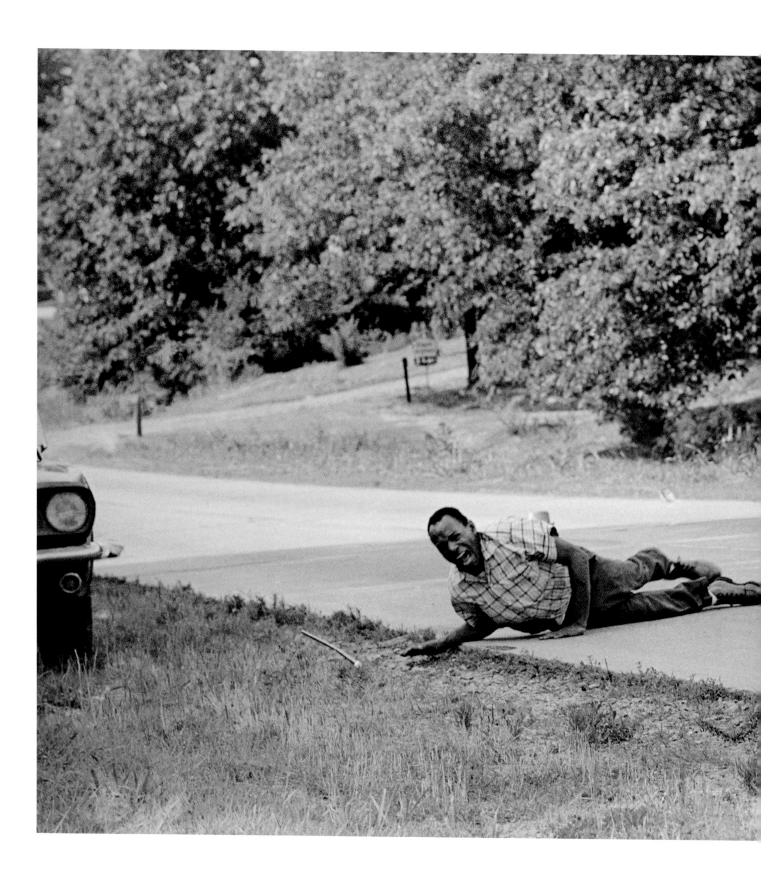

8

assassin lying in wait fired three shotgun blasts at Meredith shortly after he had crossed into Mississippi.

This photograph shows Meredith seconds after he was struck by two of the blasts—prostrate, in pain, and scrambling across the highway away from the shooter. The photograph was widely circulated in the press, as were detailed articles on Meredith's medical treatment and the many civil rights leaders who went to visit him in the hospital. Within days SCLC, CORE, and SNCC rebranded the March against Fear as "Meredith's March" and gathered thousands of volunteers to complete the journey and register black citizens along the way.

The photograph may not show the shooter, but its adherence to the standard formula for depicting white aggressors and their black victims is clear. Felled by the unseen gunman, Meredith is pictured as the classic helpless victim. It is noteworthy that this photograph—of a perfect victim—was the first photograph chronicling the civil rights struggle to win the Pulitzer Prize for photography.

9. Joe Holloway Jr. *Freedom Rider Jim Zwerg Hospitalized after His Beating*, **Montgomery, Alabama, May 21, 1961. UPI © Bettmann/Corbis.**

The next four photographs illustrate the white fascination with images that depict white suffering. Photographs of white civil rights victims were comparatively rare but received disproportionate attention in the white media. While images of black suffering struck white Northerners as "normal," those of white victims were noteworthy because of their aberrance.

Jim Zwerg grew up in the all-white community of Appleton, Wisconsin. His parents' belief in racial equality, along with his religious upbringing, experience sharing a college dorm room with a black student from the South, and time spent at Fisk University as an exchange student convinced him of his moral obligation to take up the civil rights struggle. Zwerg joined SNCC and was among the ten reinforcements who traveled from Nashville to Birmingham in response to the violence that greeted the first two Freedom Rider buses in Alabama.

produced in Chicago and not imported from the South or a one-off created by the boy. It is striking that less than a generation after the close of World War II, some whites preferred to ally themselves with German Nazis over American blacks.

Newspapers and magazines that reported on civil rights issues in the 1960s displayed a hunger for photographs showing racist and violent whites. The media published a steady stream of images depicting black and white victims, as we have seen, but they also reproduced photographs of Klan rallies, of cross burnings, and of average-looking white people holding racist signs publicizing their beliefs. The photographs of whites holding extreme views on race offered more comfort than challenge to middle-of-the-road and liberal whites: most saw in the photographs political beliefs that were nothing like their own, and the images allowed them to distance themselves from such "racists." Reassured that they were nothing like the counterprotestors in Chicago, well-meaning whites missed an opportunity to consider which values most whites shared. While few whites in 1966 allied themselves with Nazis, many did support the restrictive racial covenants used to exclude black renters and buyers from particular homes and localities; bank's redlining policies for mortgages, which ensured that blacks could not get federally backed financing for homes in white neighborhoods; and public-school financing formulas based on local real estate taxes, which benefited wealthy white neighborhoods. All of these were practices and policies that unfairly advantaged whites and against which CCCO and SCLC fought.[11]

HISTORICAL PRECEDENTS

Nothing about this Civil War–era portrait of a soldier is note-worthy aside from the man's race. Sergeant Strawn has struck a standard pose for white men of power: standing in uniform; facing the camera directly against a painted landscape back-drop with an elegant balustrade; his right hand resting firmly on a table and a sidearm displayed prominently in his left. This unremarkable pose is nonetheless radical for the black soldier's insistence on seizing a manner of representation that until recently was the exclusive purview of whites. His power is expressed most obviously by his sidearm, but also through his appropriation of signs of a manly identity, evident in his pose, uniform, and direct gaze.

While we know little about this man's history—whether he was formerly a slave or born free, laborer or professional, Northern or Southern—his emphatic expression of self-determination is clear. Much as the more typical historical precedents in this section offered prototypes for the canonical photographs of the civil rights movement, this rarer image of black strength suggested a counterprototype for progressive twentieth-century photographers and publishers who sought models for depicting black power.

DOCTORED

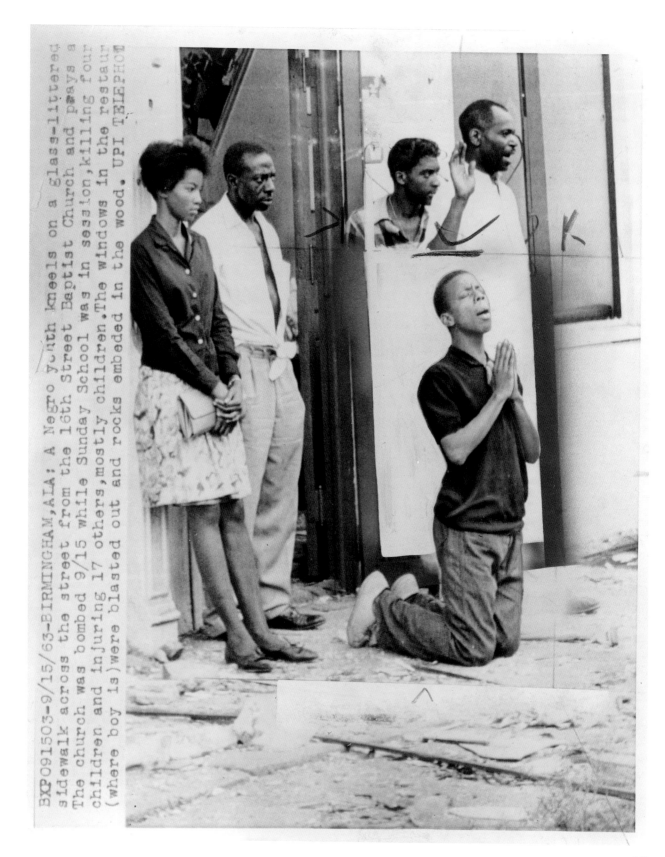

BXP091503-9/15/63-BIRMINGHAM,ALA: A Negro youth kneels on a glass-littered sidewalk across the street from the 16th Street Baptist Church and prays a The church was bombed 9/15 while Sunday School was in session,killing four children and injuring 17 others,mostly children.The windows in the restaur (where boy is)were blasted out and rocks embeded in the wood. UPI TELEPHOT

17

17. Joe Chapman, *A Negro Youth Kneels on a Glass-Littered Sidewalk*, Birmingham, Alabama, September 15, 1963. UPI Telephoto. Library of Congress, Prints and Photographs Division, Washington, DC.

On September 16, 1963, the *New York World-Telegram and Sun* published a tightly cropped photograph of a kneeling black youth praying alone on a debris-strewn sidewalk. The image illustrated a story on the Ku Klux Klan's bombing of the Sixteenth Street Baptist Church in Birmingham, Alabama, the day before.[14] The Klan was infuriated that white municipal and business leaders in Birmingham had recently agreed to modest concessions in the hiring policies at downtown department stores—likely to lead to more jobs for blacks— and aimed to scuttle the accord by prompting a popular white backlash. The Klan's expectation was that blacks would respond to the bombing by rioting, and their hope was that black violence would raise sufficient fear among Birmingham's whites for them to repudiate the recently signed agreement.

Joe Chapman, working for United Press International, arrived at the scene shortly after the blast on September 15 to record the aftermath. He photographed five black Birmingham residents who had emerged from a restaurant across the street from the church to survey the damage. The image reproduced here is a production print used by an editor at the *New York World-Telegram and Sun* with his editorial instructions for altering the photograph preserved. The editor elected not to reproduce the entire photograph of the four adult figures standing in front of the restaurant's entrance behind the kneeling boy. Grease-pencil marks above the boy's head and below his shin indicate how the photograph was to be cropped. We can see that the editor has already had the torsos and lower bodies of the two standing men on the right airbrushed out of the background. A facsimile of the restaurant's front door has replaced their bodies.

New York editors, no less than Alabama Klansmen, understood that violent, or even angry, blacks held the potential to make whites fearful. Given their different political outlooks,

the editors hoped to further racial harmony by shielding their readers from such images, while the Klansmen hoped to inflame racial animosity by making such threatening blacks impossible to avoid. So determined were the editors to present a "safe" depiction of blacks that they edited out of Chapman's photograph the elements likely to concern their readers. While the standing figures' emotions and attitudes are difficult to read with any certainty, it is clear that their inclusion in the image would have introduced a hint of narrative ambiguity at best and a threat of black violence at worst. In excluding the standing figures and focusing attention on the kneeling, praying boy, the editors ensured that their readers would see Birmingham's blacks as both religious and benign: the boy did not turn to violence (or to any other forceful response) in the face of the Klan's provocation; instead, he looked peacefully for God's guidance, comfort, or aid.

18. "The Spectacle of Racial Turbulence in Birmingham: They Fight a Fire that Won't Go Out," *Life*, May 17, 1963. Text © 1963 The Picture Collection Inc. Reprinted with permission. All rights reserved. Photograph by Charles Moore. © Charles Moore/Black Star.

The day after fire hoses and dogs were set against antisegregationist protestors in Birmingham, Americans throughout the North saw explicit pictures of the violence on television and in newspapers, though the most famous images of May 3 would not appear for another two weeks. On May 17 *Life* magazine published photographs taken by Charles Moore (see numbers 4 and 5) in an eleven-page photo-essay on the conflict. The magazine was known for the skill of its photographers and the quality of its large-format reproductions. With nearly 19 million paid subscribers at a time when the U.S. population was just over 180 million, *Life* had the largest circulation of any news source and was among the most influential periodicals of the 1960s. The next three entries explore how *Life* presented its famous photographs to the nation.

The *Life* editors were sympathetic to the black freedom struggle but strove to present what they saw as balanced coverage

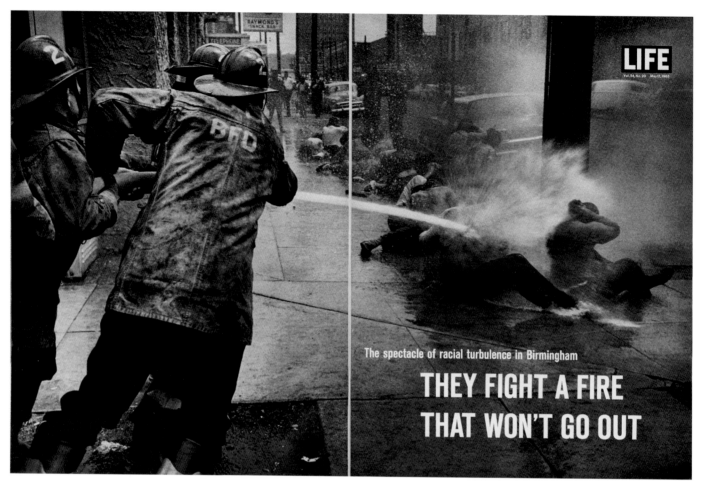

The spectacle of racial turbulence in Birmingham

THEY FIGHT A FIRE
THAT WON'T GO OUT

18

of the clash. They declared these photographs "frightening," for example, but explained this was due both to "the brutal methods being used by white policemen" and the Negro strategy that "invites that very brutality—and welcomes it as a way to promote the Negroes' cause." While the editors sought to treat evenhandedly the white and black participants in the conflict, their selection of photographs and crafting of captions and text often aligned their readers with Birmingham's whites.

The *Life* photo-essay opened with this two-page layout, showing three firemen aiming their hose against a group of protestors who sit on the sidewalk and hold their arms protectively to their heads against the force of the water. Across the bottom of the image the editors superimposed the title of the article: "The Spectacle of Racial Turbulence in Birmingham." Consider that because viewers are positioned behind the firemen and symbolically occupy the space of the city's public-safety officials, we watch the scene from much the same vantage point as the firemen themselves. Since Moore had relatively free access to the park and streets where the protests took place, consider what a different impression could have been conveyed by photographs shot from the vantage of the protestors facing the blast of the hose.

Directly under the figures of the protestors, the editors placed in bold the subtitle of the essay: "They Fight a Fire that Won't Go Out." While it attests to the determination of the protestors by metaphorically linking them to a fire and asserting that it will not be extinguished, this subtitle once again frames the action from the standpoint of Birmingham's whites: "they" are self-evidently the white firemen who fight against the black fire and on whose side we, the readers, are visually placed. The bravery, organizational skill, and determination of Birmingham's nonviolent protestors notwithstanding, it was rare for even liberal publications to use photographs or text to present events from the perspectives of blacks. In subtly aligning their readers with Birmingham's conservative white residents, Moore's photographs had the unintended effect of nudging readers into closer identification with the depicted police and firemen.

19. Charles Moore, *Birmingham Protestor*, Birmingham, Alabama, May 3, 1963. © Charles Moore/Black Star.

20. "Face of Hatred," *Life*, May 17, 1963. Text © 1963 The Picture Collection Inc. Reprinted with permission. All rights reserved. Photograph by Charles Moore. © Charles Moore/ Black Star.

His wet shirt plastered against his solid torso and drops of water running down his face and neck, a black protestor grips his waterlogged hat. He looks to his left, at something we cannot see. Moments ago he was struck by fire hoses turned on antisegregationist marchers at the orders of Birmingham's public safety commissioner, Bull Connor.

The original photograph (number 19) was cropped for its publication in *Life* to focus attention on the waterlogged man, but the image was not otherwise altered. However, when it is seen in the context of the spread where it was first published (number 20), it is apparent that the editors guided their readers to interpret the photograph's significance in a particular way. It is printed under the headline: "The Hatreds Grow as Indignities Mount." Its caption reads: "FACE OF HATRED. Glaring sullenly at firemen who just soaked him with hose jet, Negro expresses Birmingham's long-standing racial bitterness."[15]

Nowhere in the article does *Life* ever refer to the hatred of white public officials, firemen, or police who either ordered the use of or wielded fire hoses and dogs against largely nonviolent protestors. It is telling that a nonviolent activist working for the integration of the races is judged to be hateful, while the violent defenders of the separation of the races are not. The attribution of hate to the depicted man would make sense if *Life*'s reporters had solicited, and its editors printed, an interview with the man to prove their point. They did not. In an eleven-page article devoted to the civil rights struggle in Birmingham, not a single black participant or observer was quoted. While it may seem obvious to twenty-first-century viewers that the man is concerned or upset, having this individual stand for the "face of hatred" is a significant leap. In the end, the addition of the headline and caption does more to express the expectations of *Life*'s white editors than it does to illustrate the attitudes and motivations of Birmingham's blacks.

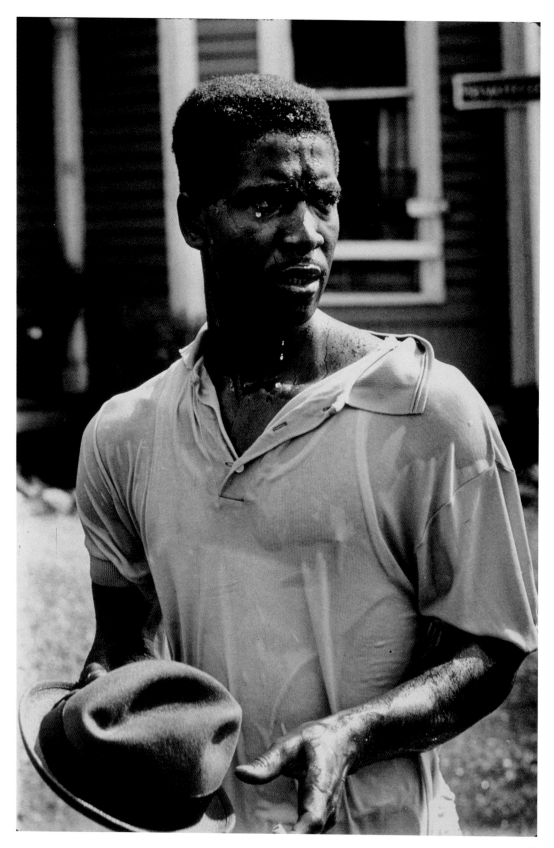

19

THE HATREDS GROW AS INDIGNITIES MOUNT

FACE OF HATRED. Glaring sullenly at firemen who just soaked him with hose jet, Negro expresses Birmingham's long-standing racial bitterness.

PASSIVE RESISTANCE. Refusing to walk, arrested demonstrators make police officers drag them bodily to wagons for transportation to jail.

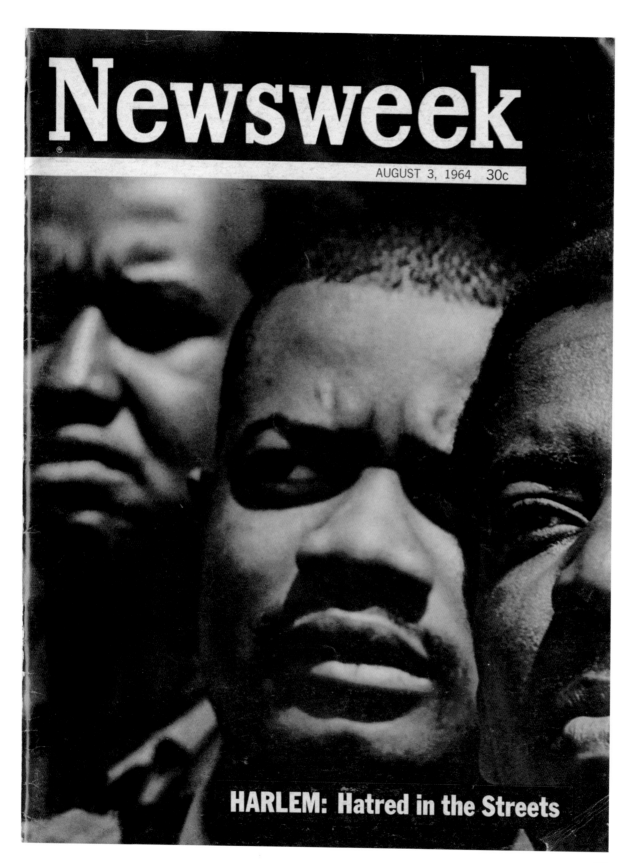

Newsweek

AUGUST 3, 1964 30c

HARLEM: Hatred in the Streets

21. Roy DeCarava, *Newsweek* cover photograph, August 3, 1964. © Newsweek Inc. All rights reserved.

In July 1964 Harlem, and later Brooklyn, erupted in ten days of clashes between incensed black youths and the police. The riots were sparked by an altercation between a white building superintendent and black high school students on their way to summer school in a white Manhattan neighborhood. When the irate superintendent turned his hose on the students and called them "dirty niggers," the youths fought back with bottles and trash can lids. An off-duty white police lieutenant responded to the altercation by shooting dead a black fifteen-year-old boy. The community in Harlem answered the shooting with demonstrations, looting, and numerous attacks on police. Black leaders such as Bayard Rustin (see number 31) and James Farmer were brought in to calm youthful tempers, but the young people had little interest in hearing from movement veterans.

Roy DeCarava, a black photographer based in New York City, was hired by *Newsweek* to shoot photographs of the conflict for a cover story. Beginning in the middle of the 1960s and greatly accelerating toward the decade's close and into the 1970s, white media outlets hired black reporters and photographers to cover "Negro" stories. The mainstream media made such hires because they came to believe that white reporters were unable to safely travel in black communities and get nonwhite interviewees to speak freely. Their motivation was not—yet—to overcome their legacy of giving preferential treatment to whites.

DeCarava did not produce the dramatic photographs of violence that *Newsweek* surely sought. We know from the instructions then given to reporters and photographers, and from the coverage itself, that mainstream media outlets thirsted for dramatic scenes of racial strife. DeCarava supplied a more ambiguous image, showing close-ups of three black faces. Unbeknownst to the magazine, all of the pictured men were photographers in DeCarava's circle unconnected to the riots.[16]

Newsweek had no problem making an image with an ambiguous narrative fit its need for drama. Much as with *Life*'s handling of the photograph of the hose-drenched man from the previous year, *Newsweek*'s editors appended text that established a clear meaning for the photograph, even though it bore no relation to the men's attitudes or actions. White Americans' predisposition to see blacks as angry, and to read virtually any group of nonwhites as a mob, allowed the magazine to readily transform DeCarava's three friends into symbols of Harlem's "hatred in the streets."

22. Matt Herron, *Bombed Church, Birmingham, Alabama*, September 17, 1963. © Matt Herron.

When Matt Herron arrived to photograph the aftermath of the bombing of the Sixteenth Street Baptist Church in Birmingham in September 1963, the scene was calm. The bodies of the four black children killed in the attack had been removed, as had the many wounded. As he surveyed the bombed church, it struck Herron that the harm done to the building was not particularly dramatic. The solid brick-and-stone church was damaged, but not to the extent he expected after a bombing.[17]

Since civil rights photographers had a much better chance of having their photographs taken seriously by editors and the public when they captured dramatic scenes, many of the reporters who covered the church bombing trained their lenses on stained-glass windows blown out in the blast, mangled parked cars damaged by debris, and, occasionally, concerned spectators crowding the sidewalks. Without victims to photograph, they often looked for inanimate stand-ins capable of conveying the force of the blast and suggesting the damage done to the unseen human beings.

To heighten the drama of the scene, and to make clear the severity of a blast that had claimed four black lives, Herron crawled into a damaged car to shoot a photograph of the church through the shattered windshield. The resulting photograph provides a human dimension to the carnage by taking

as its vantage point the front seat of a damaged car. It works to place viewers at the scene and to encourage their vicarious experience of the blast's force.

In the early 1960s Herron shot scenes of civil rights activism in coordination with SNCC. A white man who was deeply committed to the civil rights movement, he never considered himself a neutral observer of events. He wanted his photographs of the civil rights movement to be catalysts for changing minds and moving U.S. society. As Herron surveyed the bombing site, he was intent on creating images that would convey to white Americans the gravity of the incident, as he understood it, rather than simply providing a dry account of the damage done to a structure. Herron's "manipulation" of the scene differed in degree from that of the airbrushing editors of the *New York World-Telegram and Sun* (number 17), even as his decisions regarding the framing of his photograph were motivated by a like desire to guide viewers' perceptions of an event. It is easy to condemn the airbrushing of news photographs and to judge the choices photographers make in framing more benignly, yet both exert a significant impact on viewer perceptions. While Herron engaged in nothing more than a common strategy in news photography to this day, his image suggests how complicated it is to believe in photographs capturing the simple "truth" of events.

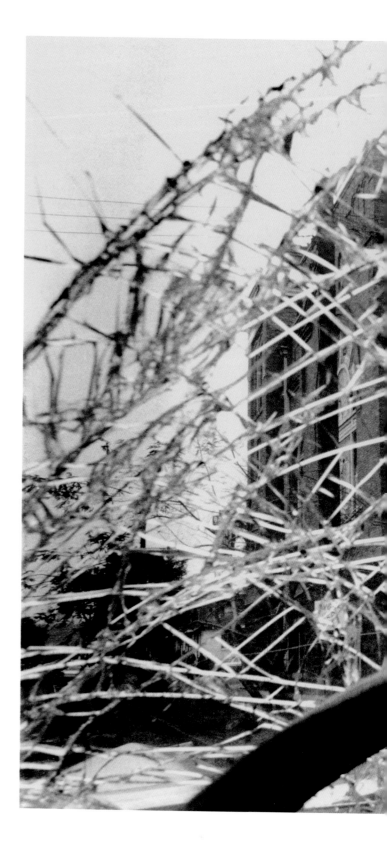

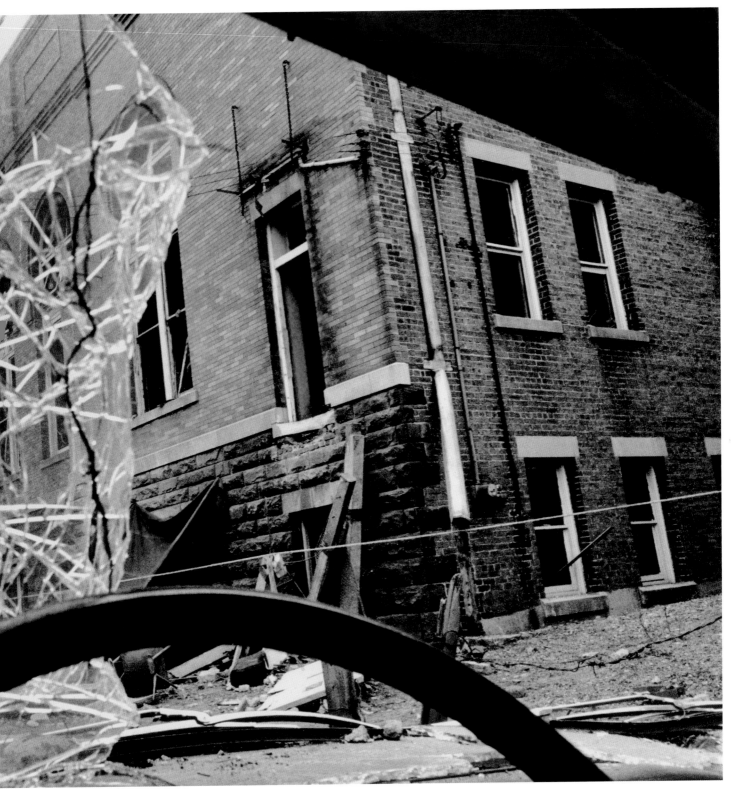

STRENGTH

23. Unidentified photographer, *Moses Wright on the Witness Stand in Sumner, Mississippi,* **September 22, 1955. UPI/Corbis-Bettmann.**

On a sweltering September day in a small Mississippi courtroom, Moses Wright testified about the late-night abduction of his fourteen-year-old great-nephew, Emmett Till. The family never saw the boy alive again.

Till was killed during a summer vacation spent with his maternal relatives in rural Mississippi. His mother, Mamie Bradley, consented to his request to travel from Chicago to spend two weeks in the South. The murder was precipitated by a verbal exchange between Till, who was black, and Carolyn Bryant, a white woman working the counter at a local general store. While the precise nature of the interaction has long been in dispute, the most plausible reports have the boy showing off to his black friends by saying "Bye, baby" to Bryant as he exited the store. What is clear is that Till acted in a way that upset the rigid racial etiquette then enforced by whites in governing relations between the races in the Deep South.

Several days after the incident at the store, Till was roused from bed and abducted by the aggrieved woman's husband, Roy Bryant, and her brother-in-law, J. W. Milam, who sought "the nigger who did the talking." Till was subsequently tortured by the men for hours in a nearby barn, shot in the head, stripped of his clothing, and dumped into the Tallahatchie River, weighted down with a massive cotton-gin fan secured with barbed wire to his neck. His partially submerged and decaying corpse was found three days later with an eye hanging out of its socket, dramatic skull fractures, and a broken femur and wrists.

The Till murder and trial received front-page coverage in both the white and black press, even as reporters for each focused on different aspects of the story. White media attention revolved around the novelty of Southern whites on trial for the killing of a black boy and the injustice of the acquittal. Black coverage devoted more attention to the actions of blacks. In other words, beyond chronicling the choices made by the white murderers and jury, black newspapers and magazines illuminated constructive black responses to the crime.

Central to the story told by the black media was the testimony of Wright. Till's great-uncle took the unprecedented step of testifying against Mississippi whites in court. At the moment shown in the photograph, Wright rises from the witness chair to point out for the jury the men who abducted Till. The grainy and poorly framed photograph was shot surreptitiously in court because the presiding judge had barred the taking of photographs during testimony. Its poor quality lends it the authentic look of a surveillance photograph. The caption for the image in the black-owned *Jet* magazine read: "Brave Moses Wright stood up to point accusing finger at kidnappers."[18] Southern whites were shocked at his audacity, and blacks across the United States were inspired by his courage to make their disgust with the treatment of blacks in Mississippi a national cause.

In many ways events following the Till murder offered a story of black action, even if those events were only sporadically covered in the white press. Not only did Wright testify, but Till's mother famously insisted on an open-casket funeral so that the world could "see what they did to my boy," and tens of thousands of ordinary blacks lobbied Congress for anti-lynching legislation, wrote to President Eisenhower asking that he publicly support their cause, held antilynching rallies, raised large sums of money to support the work of the NAACP, turned out in unprecedented numbers to attend Till's viewing, and read about his life in the black press. For millions of blacks the photograph of Wright in court was both a symbol of black heroism and a spur to further action.

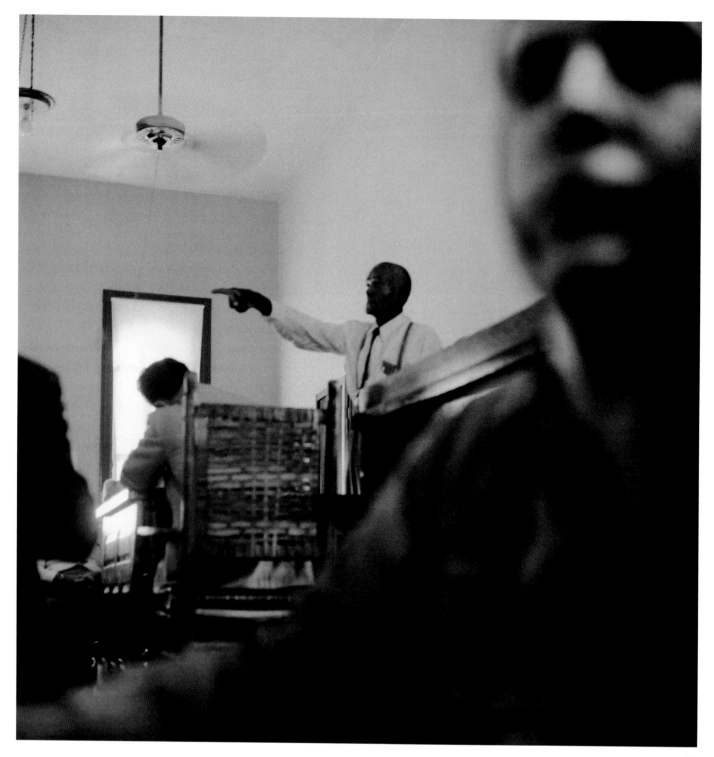

23

24. Bill Hudson, *Police Dog Lunges at a Protester,* Birmingham, Alabama, May 3, 1963. AP/Wide World Photos and Bill Hudson.

When Northern white papers broke news of the "Children's Crusade" in Birmingham in early May 1963 with prominent, front-page articles, many chose to illustrate their stories with this photograph of a lunging police dog. The Children's Crusade was the culmination of more than a month of protest, precipitated when Dr. Martin Luther King Jr. acceded to the urging of a handful of his more radical associates and allowed child marchers to demonstrate against Birmingham's segregationist ordinances. Almost as soon as the young protestors took to the streets, the city's public safety commissioner, Bull Connor, unleashed police dogs and high-pressure fire hoses against largely peaceful demonstrators. Captured by half a dozen photographers, the dramatic pictures of violence were quickly published throughout the North and around the world.

Bill Hudson's photograph could be readily grouped with the canonical photographs of the civil rights struggle, for not only was it a popular image, but it also neatly encapsulated the dominant story then told about the movement. Most white newspapers and periodicals used the photograph to illustrate stories on the "victimized," "passive," and "submissive" blacks of Birmingham. As one newspaper reporter who was highly sympathetic to the black struggle for civil rights wrote of the photograph: "[A] grinning cop set[s] his savage dog at

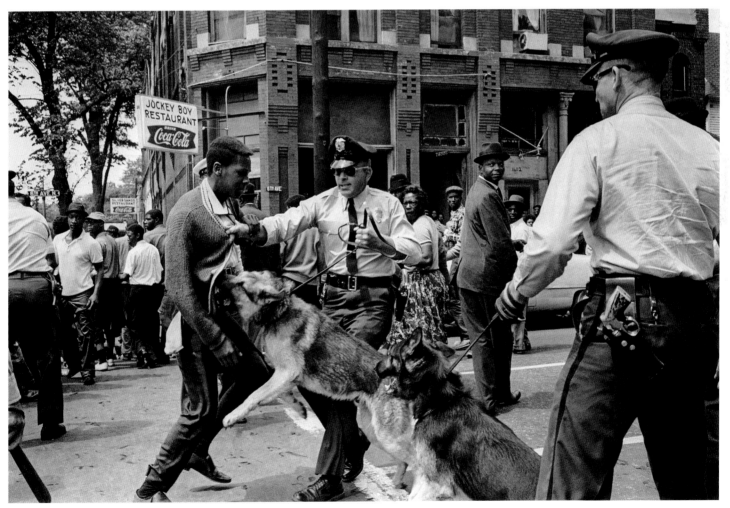

the throat of a frail Negro."[19] And yet the photograph is reproduced in this section of the catalogue because for many black Americans in the 1960s it illustrated strength.

Throughout the 1960s, when white media outlets published breaking stories on civil rights events, they rarely quoted black participants. Reporters sometimes gathered quotes from the leaders of protest movements, even as the many thousands of ordinary volunteers who marched and demonstrated in the streets were ignored. As a result, when images of unidentified protestors were reproduced, the photographic captions often had little correspondence with the attitudes, beliefs, and, at times, even the actions of the depicted figures. This was precisely the case with this well-known photograph.

The black press approached civil rights stories from a different angle. When the black-owned publication *Jet* reproduced Hudson's photograph in May 1963, it paired it with an interview of Walter Gadsden, the black fifteen-year-old who confronts the dog. As Gadsden explained to the *Jet* reporter, he grew up in a household with large animals and a father who insisted that he learn how to defend himself from attack.[20] At the moment pictured, Gadsden has jerked his left knee up in an attempt to ward off the dog's bite and break its jaw. Look closely and you'll also notice that the boy's left hand tightly grips the policeman's right wrist. Depending on your point of view, Gadsden is either defending himself or fighting back, but in no case is he the passive recipient of a violent attack. We know from the interview in *Jet* that Gadsden was not even a protestor that day in May, but simply a curious boy who went downtown to check up on his protesting classmates. His father was a conservative black publisher who had little sympathy for the protest movement and the publicity King and SCLC brought with them to Birmingham.

The publication history of the photograph dramatizes the degree to which the meanings of images hinge on the contexts in which they are presented to readers. In addition, Gadsden's expressed disinterest in the civil rights protests reminds us that black Americans in the 1960s were not a monolithic group. There were significant numbers of blacks who declined to support civil rights activism, some out of well-grounded fears for their lives and their jobs, and others out of disagreement with the politics or tactics of the leading civil rights organizations. What made this a characteristic image of the civil rights struggle to many whites was a misinterpretation of Gadsden's mindset, and what made it one to many blacks was the boy's commitment to act, regardless of his attitude toward the organizing efforts of SCLC. While the meaning of the photograph appeared self-evident to most reporters and newspaper readers, black and white, its social significance was both contradictory and complex.

25. Bill Hudson, *Man with Knife Attempting to Stab Police Dog, Birmingham, Alabama*, May 3, 1963. AP/Wide World Photos and Bill Hudson.

In the early 1960s black and white volunteers for civil rights protests sponsored by SCLC (and most of the other major civil rights organizations) were required to conduct themselves nonviolently. Some SCLC leaders were committed to nonviolence as a way of life, and others saw it as an effective tactic, but all agreed that black protests could only secure broad national support if they remained peaceful. Even when just a tiny minority of civil rights protestors in a given action resorted to violence, white media outlets turned against the cause.

During demonstrations in Birmingham, protestors affiliated with SCLC remained nonviolent, but the same could not always be said for black bystanders. At the height of the conflict in early May, many local blacks came out each day to observe the clashes between activists and public-safety officials. From time to time such unaffiliated citizens were drawn into the conflict through their outrage over police tactics. Many of them hurled taunts, some threw bricks and bottles at authorities from a distance, and a few confronted the police up close. The unnamed black man in this photograph was one such bystander who responded to violence with violence.

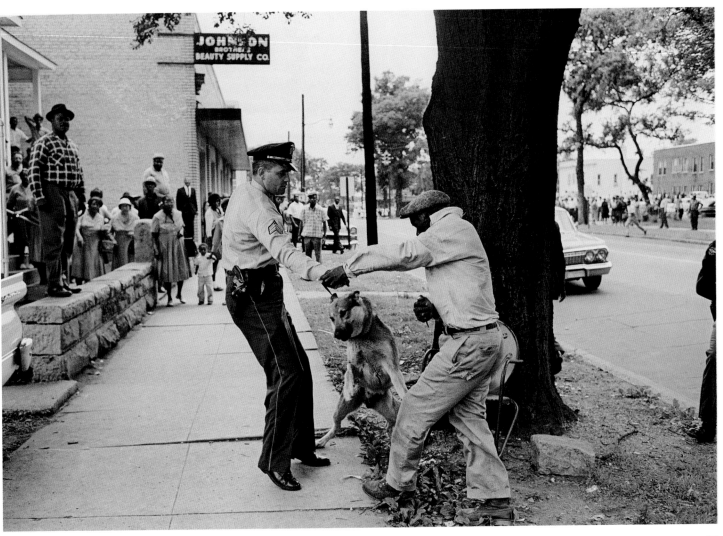

Horrified at the sight of the policeman allowing his dog to attack unthreatening protestors, this man pulled out a small penknife, which he holds blade down in his right hand, in an effort to stab the dog. From virtually every major protest action we have photographs or reports of black citizens driven to violence by either the legacy of brutality to which they were subject or the immediate threat posed by the police or mob. These acts of violence were often performed in self-defense or in defense of others, but they did not conform to the non-violent ideal espoused by movement leaders.

Such photographs were frequently reproduced in the black press to illustrate the extremes to which upstanding black citizens were driven by Jim Crow society. In reporting on the use of dogs against protestors in Birmingham, the black-owned *Pittsburgh Courier* reproduced three photographs under the headline: "Dirty Dog Tactics Used in Birmingham." The first illustrated a dog attacking a youth; the second, a boy using his sweater as a cape to taunt a policeman and his dog; and the third, a close up of this unnamed Birmingham resident trying to stab the police dog.[21] Note that two of these three photographs illustrate blacks taking charge of the situation and not simply suffering the attack of the white police. This was a theme that black newspapers presented to readers who were heartened by scenes of blacks actively protecting themselves and their communities.

26. Danny Lyon, *John Lewis, March on Washington*, Washington, DC, August 28, 1963. Courtesy of Danny Lyon and Magnum Photos.

When Americans today think about the March on Washington, they picture aerial shots of seemingly endless crowds on the mall, integrated groups of protestors with their placards, a close-up of a Hollywood celebrity or two chatting with civil rights leaders, and, above all, photographs of Dr. Martin Luther King Jr. gesturing against the backdrop of the Lincoln Memorial in the midst of his celebrated "I Have a Dream" speech. For many Americans today, the image of King envisioning a day when his children "will not be judged by the color of their skin but by the content of their character" is the essence of the march.

Yet for many black activists that summer, the march—and King's speech in particular—were disappointing. Malcolm X railed against the black organizers of the march who made, in his estimation, too many compromises to white authorities. As he explained to a Detroit audience in the fall of 1963, "They ceased to be angry. They ceased to be hot. They ceased to be uncompromising. Why, it even ceased to be a march. It became a picnic, a circus." James Forman of SNCC scoffed that "King spoke about his dreams while black people lived in nightmares." The student activist Anne Moody spoke for many of the younger radicals who attended the March on Washington when she lamented having "sat on the grass and listened to the speakers, to discover we had 'dreamers' instead of leaders leading us."[22] Moody did not plan to wait for a new racial day to dawn; she wanted a roadmap to aid blacks in driving immediate change.

While it is not popularly recalled today, the original plan for the march envisioned 100,000 protestors descending on Washington, DC, to draw public attention to the "economic subordination of the American Negro" and the need for a "broad and fundamental program of economic justice" for the nation. The plan imagined a "mass descent" on Congress that blocked all legislative business, while a smaller group visited the White House. Both congressional leaders and the president were to be presented with specific legislative demands. The second day of the march was to be devoted to a mass protest rally.[23] The march that unfolded was a much tamer affair, in part because of intense pressure brought to bear on the organizers by white politicians, including the president, and in part because of the need felt by several of the more established civil rights leaders who sponsored the event to win over, rather than alienate, white America. March leaders knew that media coverage would give black America its best opportunity to speak directly to many millions of whites whose understanding of the civil rights movement was derived almost wholly from white reporters and newscasters. Live television coverage by ABC, CBS, and NBC allowed blacks to speak directly to their white fellow citizens. This was an

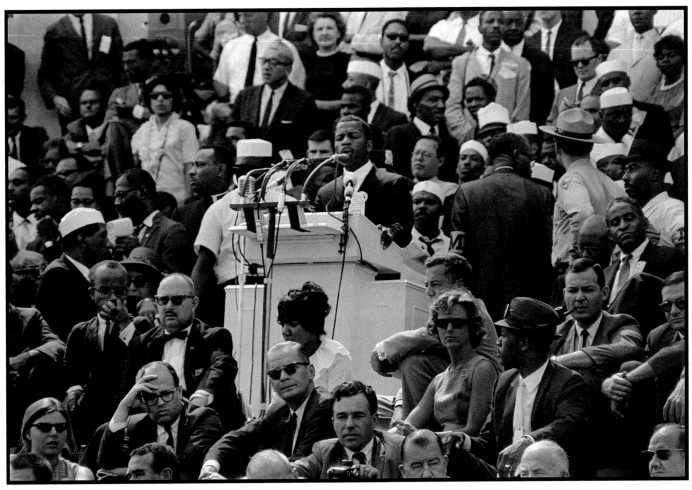

26

opportunity that moderate civil rights leaders were determined not to squander.

This photograph shows John Lewis, chairman of SNCC, delivering his speech at the March on Washington from behind a podium filled with microphones. Arrayed behind him on the steps of the Lincoln Memorial are scores of dignitaries, several reporters, and, at the upper left, a network television camera. When photographs of the march are published today, those showing Lewis's speech are rarely among them. It is not coincidental that he was one of the few speakers to call for the immediate change that many radical activists hungered to hear. Lewis faced significant pressure from a handful of black leaders to tone down his rhetoric in the minutes leading up to his address. Despite making some last-minute modifications in his language, Lewis delivered the day's most fiery call for black action. He declared, "The revolution is at hand, and we must free ourselves of the chains of political and economic slavery.... We will not wait for the courts to act, for we have been waiting for hundreds of years. We will not wait for the President, the Justice Department, nor Congress, but we will take matters into our own hands and create a source of power, outside of any national structure."[24]

The mainstream media had little use for images that distracted from the safe and patient dream of equality invoked in King's oration. This photograph of Lewis and his address are useful aids for pushing us to see this long-canonized event as both more tame and radical than is popularly recalled today.

27. Danny Lyon, *Members of the Student Nonviolent Coordinating Committee (SNCC) Sing Freedom Songs during the March on Washington,* Washington, DC, August 28, 1963. Courtesy of Danny Lyon and Magnum Photos.

The March on Washington was filled with music, as was the civil rights struggle it promoted. In addition to a roster of prominent speakers, the march featured many famous singers. Marian Anderson opened the program with "The Star-Spangled Banner." Other performers that day included Joan Baez, Bob Dylan, Mahalia Jackson, Odetta, and Peter, Paul, and Mary.

This photograph is a close-up of SNCC members on the mall joining together in freedom songs. The two figures in the foreground wear jeans, which was the unofficial uniform of SNCC. One sings and claps as the second extends his right arm and snaps his fingers. Danny Lyon, the SNCC photographer who took this photograph, shared with many younger radicals the sense that the organizers of the march had compromised too much and lost the event's militant edge. Lyon criticized organizers for excluding from the program freedom songs that had the potential to strike a mass television audience as "provocative." Lyon notes that once the program had ended and the majority of marchers made their way back to waiting buses, SNCC members joined in singing the important movement anthems that had been excluded from the official program. As Lyon recalled, "Singing became a brief moment of defiance."[25]

Freedom songs were routinely wielded by activists in the South as a nonviolent weapon against white crowds and law-enforcement officials who denied black rights. At the DC march, SNCC members turned this standard weapon against the more established civil rights leadership. SNCC chose to mark its distance from civil rights moderates by singing radical protest songs and through the creation of a photograph that visually isolated its members from the mix of people and organizations that gathered on the mall. The photograph draws attention to the many fissures that separated the eclectic groups that propelled the drive for black civil rights. While many whites feared that race was the major divide separating Americans, the integrated members of SNCC believed that one's political outlook was far more consequential.

28. Student Nonviolent Coordinating Committee, *NOW*, 1963. Offset print on paper. Tamiment Library, New York University.

SNCC subsequently turned Danny Lyon's photograph of participants at the March on Washington into a fund-raising poster. The organization's philosophy was economically reduced to the bold, one-word exhortation: "NOW." The poster may be seen as a visual analog to John Lewis's speech

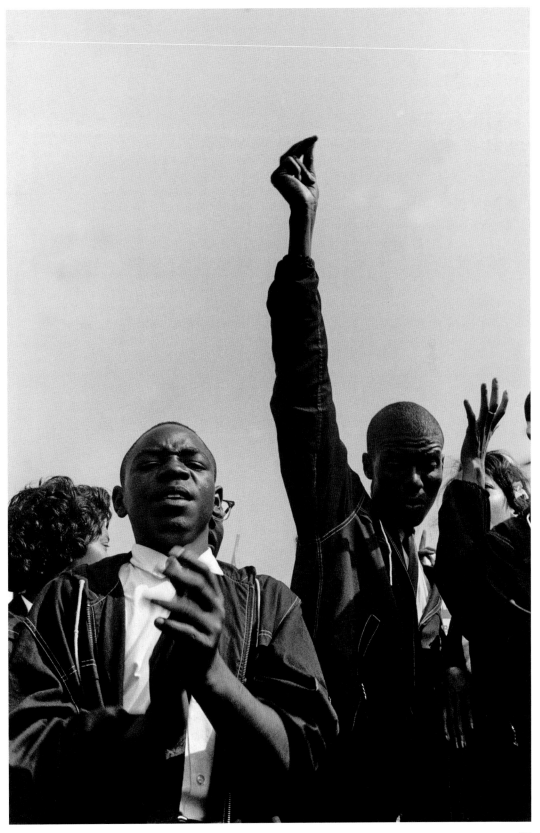

at the march (see number 26), as both made clear SNCC's aim of driving immediate change.

The poster was controversial. In the 1960s many white liberal supporters of civil rights cautioned blacks that it was unwise to move too quickly. Reforms would come, they argued, but change needed to come slowly to avoid a white backlash. Members of more radical civil rights organizations had little interest in heeding white calls for patience. As they frequently pointed out in interviews with the white press and in meetings with politicians, American blacks had waited nearly 350 years for their rights. Just how much more patience did they need to show? For SNCC's workers and supporters, calls for patience were particularly galling, given that they routinely came from whites (and blacks) far removed from the realities of daily life in the Deep South. When Lewis was asked by black leaders to modify his March on Washington speech, he explained that he was giving voice to the needs and aspirations of blacks in the rural South, where his critics had spent little time. The speech, he argued, was not his to change.

Perhaps black leaders and liberal whites who urged moderation were simply being practical. They understood the political realities of how change works in a democracy and wanted to ensure that the more radical elements of the movement did not push too fast or too far. SNCC, to its credit, was intentionally impractical. "Practical" reformers set out to change society based on what is possible under the current conditions. "Impractical" organizations seek to change the current conditions and, in so doing, shift the horizon for the kinds of changes that are possible. There was nothing practical about SNCC's dogged efforts to register blacks to vote in the South in the early 1960s, and few then foresaw that the efforts would inspire Southern blacks to shake off the Jim Crow system that had oppressed them for generations. There is much to be said for the practical, step-by-step work of the NAACP—for example, in challenging segregation through the courts—but there is also a place for the impractical efforts of more visionary organizations that insist on pushing at the borders of the imaginable.

28

29. Matt Herron, *SNCC Worker Helping Resident of Belzoni, Mississippi, Fill Out Ballot for COFO Sponsored "Freedom Election" under Scrutiny of Local Police,* **October 1, 1963. © Matt Herron.**

White residents of Southern states, all of which had low rates of black voter registration, felt increasingly defensive in the early 1960s as calls for electoral reform grew among members of Congress and whites in the North. In an effort to defend their states, many Southern elected officials and newspaper editors claimed that low black registration numbers were the result of black disinterest rather than barriers to the franchise. The explanation was patently false, but feeding as it did into white-held stereotypes of blacks as apathetic and uninformed, the argument helped blunt calls for change.

In the fall of 1963 the Council of Federated Organizations (COFO), a coalition of major civil rights groups operating in Mississippi, staged a "Freedom Election." To counter white claims of black electoral apathy, and to make the case that neither the state's Democratic Party nominees nor its elected officials were legitimately chosen by all of Mississippi, COFO organized a shadow election. It established a registration system, proffered a slate of candidates, and held a massive statewide election involving as many of the state's unregistered black citizens as it could reach. COFO encouraged the fewer than 25,000 blacks who had managed to register in Mississippi to vote in the regular election by writing in the names of the candidates on COFO's Freedom Slate. To ensure that blacks (and whites) took the elections seriously, COFO set up a statewide campaign organization, ran newspaper

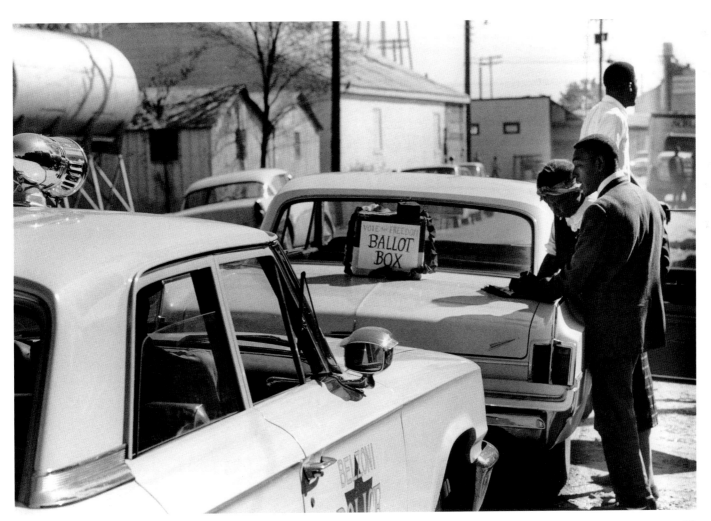

and television ads to publicize their plans, and held rallies throughout Mississippi.[26]

This photograph shows a SNCC worker helping a Belzoni, Mississippi, resident fill out her Freedom Ballot. The clearly marked ballot box sits on the top of the trunk of the worker's car. Because of difficulties inherent in getting tens of thousands of poor, rural people to the polls, the Freedom Election brought polling places to the people. We glimpse the side of a police car, a siren on its roof and "Belzoni Police" painted on its passenger door, parked immediately behind the figures. Mississippi police did everything they could to thwart the Freedom Election by harassing COFO workers and arresting them on spurious charges. The brutal legacy of police intimidation and violence against blacks was sufficiently strong that the police could tamp down voter turnout simply by surveilling polling places. But neither the worker nor voter pictured here is dissuaded by the implied threat posed by the police.

The Freedom Election saw more than 80,000 citizens cast ballots—more than three times the number of blacks registered to vote in the state. National media interest was intense, and news reports made it increasingly difficult for Southerners to argue, or believe, that the majority of black Americans had little interest in politics. This photograph suggests that blacks were not only keen to vote and promote the democratic process more generally but also willing to take significant personal risks to do so.

30. Matt Herron, *Black Citizens of Hattiesburg, Mississippi, Filling Out Voter-Registration Forms at Forest City Courthouse,* January 22, 1964. © Matt Herron.

This photograph shows two black Mississippians filling out forms to initiate the process required for voter registration at their local courthouse. The scene took place six months before the Civil Rights Act of 1964 prevented counties from enforcing different voter-registration requirements for whites and blacks and a year and a half before the Voting Rights Act of 1965 outlawed discriminatory voting practices altogether.

Prior to the implementation of these two federal acts, black Americans in the South faced exceedingly high, and unconstitutional, barriers to the franchise. Voter-registration offices were routinely open just a day or two per month and were frequently staffed by whites openly hostile to black citizens attempting to exercise their rights. Blacks in Mississippi faced poll taxes as well as tests on literacy, good moral character, and citizenship that were designed to severely limit their numbers on voter rolls. But one of the most powerful weapons that Mississippi (and many other Southern states) wielded against blacks who attempted to register was the promise of publicizing their names.

Many Americans today consider voter registration to be a private matter of personal choice. Through the mid-1960s Southern voter-registration offices routinely published the names of citizens who wished to register in local papers before the registration could be finalized. This afforded the white community the opportunity to exert social, economic, and, at times, physical pressure on blacks who tried to exercise their rights. Blacks whose names appeared in the newspaper as aspirants to the franchise would routinely lose their jobs or their white customers; they or their family members would have trouble getting bank loans or have existing loans recalled; they might lose leases on their homes; or they might be threatened with or suffer violence or even death. In publicizing the names of those who wished to register, the county gave whites the opportunity to terrorize black citizens and, as was often the case, to get blacks to "voluntarily" withdraw their applications during the mandatory waiting period.

This photograph is shot from the vantage point of the clerks working in the registrar's office. It shows two unnamed men, one middle-age and one more elderly, who stand at a tall counter in the courthouse as they pore over registration forms with pencils in hand. Behind the men on the wall above the counter is a posted sign that lays out the procedure for registration—making clear that the names of all registrants will be published for "two consecutive weeks in the newspaper." While the photograph alludes to the ways in which white citizens punished blacks who sought the vote (through

the presence of the sign and two white onlookers who hover behind the men), its focus is on the bravery of the black figures. The men quietly fill out their forms, knowing the hostility they will face and likely understanding that their chances of voting are slim. Their act of defiance is dignified and bold. It is one of the countless resolute acts that men and women whose names are now lost to history performed away from the limelight in county courthouses all across the United States.

31. Unidentified photographer, *Rustin Addresses Rally*, New York, New York, May 18, 1964. AP Images.

This photograph shows Bayard Rustin speaking to a crowd about school integration and forcefully gesticulating against the backdrop of city hall in New York City. Rustin was a longtime activist who was universally admired for his oratorical, organizational, and tactical skills. Over his long career he engaged in the civil rights struggles of black, Japanese American, African, Asian, and gay and lesbian peoples. Despite his significant contributions, he received comparatively little attention in the press.

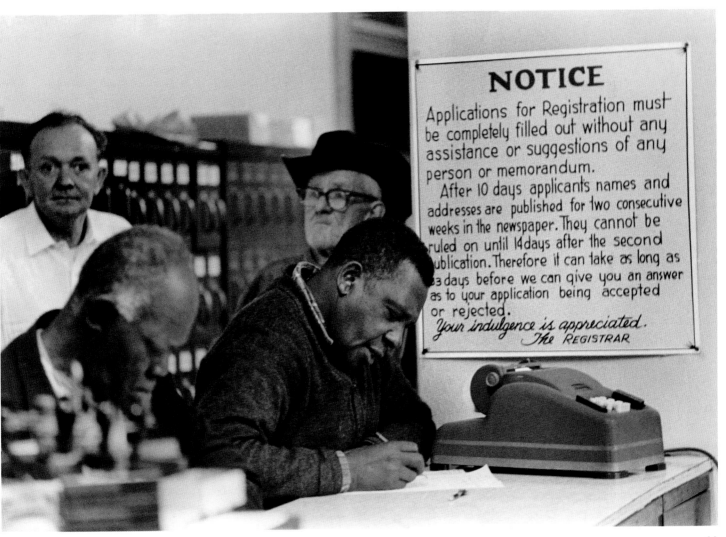

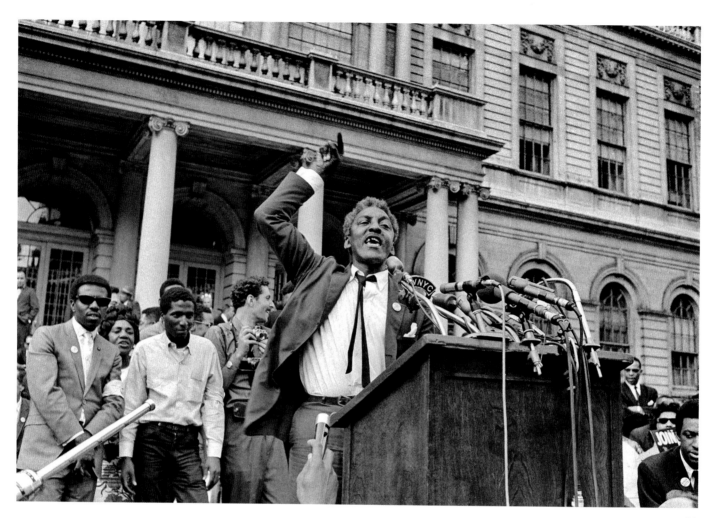

31

Raised as a Quaker, Rustin held a lifelong commitment to nonviolence. He joined the Youth Communist League in 1936 because of its progressive stance on race relations, quitting the party only in 1941. He was tapped by A. Philip Randolph to help organize a 1941 march on Washington to protest discrimination in the armed forces and defense industries. The prospect of 100,000 American blacks descending on Washington, DC, pushed President Franklin Roosevelt to enact fair hiring reforms through an executive order, and Randolph cancelled the march in grateful response. Two decades later the aborted march served as a model for the successful 1963 March on Washington, which Rustin was again charged with organizing.

As a member of the Fellowship of Reconciliation (FOR), Rustin traveled to the West Coast in 1942 and worked with the American Friends Service Committee to protect the property of Japanese Americans after their mass incarceration during World War II. He participated in FOR's 1947 Journey of Reconciliation, which saw integrated groups of riders taking buses through the South (and became the inspiration for the Freedom Rides of the 1960s). For his efforts Rustin was beaten and jailed in North Carolina, where he was sentenced to thirty days on a chain gang. Rustin advised Dr. Martin Luther King Jr. on the Montgomery Bus Boycott and helped found SCLC. He also participated in many strikes to advance union causes; championed Indian and African independence from colonial rule; worked to secure medical care, education, and food for Vietnamese "boat people"; and was active in the gay rights movement in later life.

Rustin was vastly more important to the black civil rights struggle than one would glean from press reports. The white press had a limited appetite for covering black life and tended to focus on a handful of black leaders. Since Rustin never led a major civil rights organization and spent much of his life in key behind-the-scenes roles, he did not receive the attention of some of his peers.

Attitudes about and coverage of Rustin were complicated by a political and personal life that was deemed controversial. For white and black reporters, and many civil rights activists, Rustin was too iconoclastic for comfort: Because he was a pacifist and had refused to fight in World War II, Rustin served time in a penitentiary. His criminal record only compounded concern about his long-time affiliation with the Communist party and his unapologetic attitude toward his homosexuality. Civil rights activists continually battled accusations that they were unpatriotic, communist, and homosexual. In the middle of the twentieth century, any one of these charges was sufficiently damaging to kill one's legitimacy with the American public. While movement leaders respected Rustin's skills, they pushed him into the background, fearful that Southern politicians or FBI director J. Edgar Hoover would use Rustin's involvement in a given protest action to irreparably damage the movement. As a consequence, some of the publications most supportive of civil rights downplayed Rustin's work. Photographs such as this one, which highlight his dramatic oratory skills, might have attained renown had Rustin conformed more closely to the rigid social and sexual codes that dominated mid-twentieth-century America.

32. Matt Herron, *Fire Bomb Watch*, Mileston, Mississippi, June 1, 1964. © Matt Herron.

During the Freedom Summer of 1964 Mississippi saw an influx of idealistic black and white college-age volunteers from the North who streamed south to demonstrate their support for the civil rights movement. They came to work on voter registration and community projects and in Freedom Schools and health clinics. This influx encouraged and supported an unprecedented swelling of activism.

Herron's photograph captures the white volunteer carpenter Jim Boebel (left) and a local black resident (right) guarding a recently constructed black community center that had received a firebombing threat. To ensure that the center would remain unharmed, local men took turns guarding it each night, when attacks were most likely to occur. The photograph shows the pair from behind as they watch through a darkened window for threats, a shotgun at the ready. The otherwise dark room is momentarily illuminated by the photographer's flash.

We, as viewers, are safely ensconced in the center of the room, protected by the vigilant pair.

Boebel was encouraged to donate his time during Freedom Summer by social activist and fellow carpenter Abe Osheroff. The two had arrived in Mississippi from Los Angeles in the spring of 1964, presented themselves to SNCC workers, and asked how they could help. SNCC took advantage of their expertise by directing them to build an impressive community center in Holmes County for a local black cooperative.

The photograph suggests how the building of the center was merely the start of a long struggle. Local black residents readily agreed to have SNCC build the center in their community, and several black landowners offered land on which to erect it. These were not trivial matters, for the residents knew better than anyone the threat that such a center would pose to the authority of local whites. In supporting the idea of the center and working on its construction, local families signaled their willingness to unsettle the white power structure and affirm their long-term commitment to the center's maintenance and protection.

While the photograph may hint at the potential for violence by including the shotgun, its overriding message is one of cooperation, self-sufficiency, and determination. The neatly arrayed shelves of books are indicative of the value accorded to education by black residents of Holmes County, and the construction of the center itself was testament to the importance of bringing the community together. For a small rural community in a desperately poor county, maintenance of a community center would entail significant costs. And while the photograph points to the alliance of whites from the North and blacks from the South, it was lost on no one during Freedom Summer that the thousands of volunteers would head home and leave their erstwhile black partners to contend alone with the fallout of having pushed the boundaries of Mississippi society all summer. This was a challenge that the tiny community of Mileston was willing to take on.

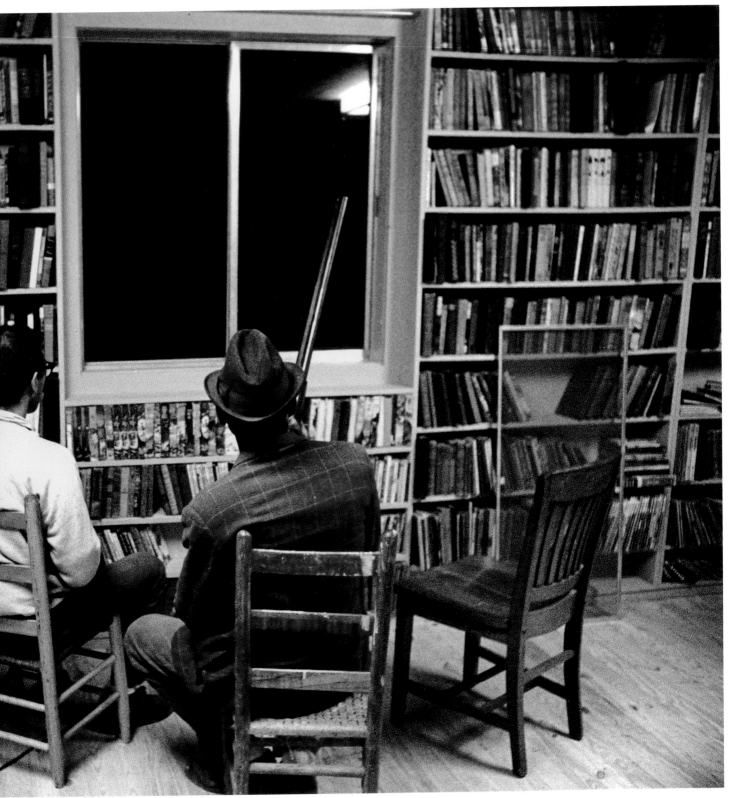

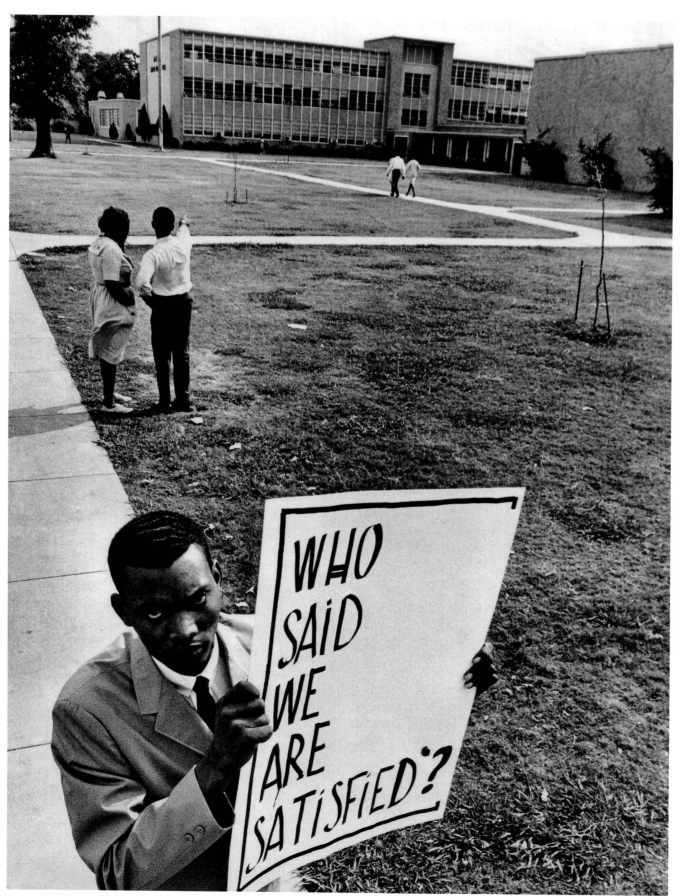

33

33. Unidentified photographer, *Picket High School*, Houston, Texas, May 10, 1965. AP Images.

More than a decade after the U.S. Supreme Court ordered the desegregation of public education, Houston had integrated its schools only through the fifth grade. The city reacted to the *Brown v. Board of Education* decision by stalling. It passed new school-board regulations intended to thwart black enrollment and filed appeals over desegregation rulings with the courts. In 1960 Houston was finally ordered to institute a year-by-year desegregation of its schools, beginning with the first grade. By 1965, however, fewer than 2 percent of eligible black children attended a previously all-white school.

In May 1965 a local black preacher organized a mass walkout of students from Houston's five remaining all-black schools. The school boycott was heeded by 90 percent of the city's black students, and the accompanying march drew 2,000 protestors. Blacks insisted that the school board implement faster desegregation efforts and accede to community demands to accept available federal aid for milk and lunch programs. Since the city had experienced comparatively little in the way of civil rights protests in the 1950s and early 1960s, the sudden appearance of a civil rights movement took many whites by surprise. White Houston was, as *The New York Times* put it, "shocked by the first mass demonstration by Negroes in nearly a half century."[27]

This photograph shows a demonstrator picketing outside Yates High School during the strike at one of the city's all-black schools. The photographer shot the protestor from above, at an angle that compresses the middle-ground space and emphasizes a link between the man in the left foreground and school buildings in the right background via the zigzagging sidewalk. The protestor looks up into the lens as he holds a neatly lettered placard reading: "Who Said We Are Satisfied?"

The text on the sign went to the heart of white fears during the civil rights era. Many white citizens expressed concern that blacks would never be satisfied with the pace or extent of reform. They saw that the end of segregated transportation policies or restrictions on black voting did not lead nonwhites to express contentment—never mind gratitude; these successes served only to spur additional demands. And this, in turn, made many white Americans in the second half of the 1960s less sympathetic to calls for additional reforms. Whites tended to see civil rights reforms as something they magnanimously did for blacks rather than a black-led drive for equal justice and opportunity. The tendency of the press and politicians to focus on the discrete ways in which whites had acceded to black calls for equitable seating on buses or integrated schools encouraged whites to interpret black demands as endless. Yet many blacks were far from satisfied with the compromises made by white Americans because the country's racial balance of power had changed so little. Through his reproduction of an unsmiling black protestor with a confrontational sign, the photographer virtually guaranteed that his photograph could not support sympathetic coverage of the Houston strike in the white press.

34. Charmian Reading, *A Blind Man and His Wife Being Helped across the Road to the Voter-Registration Office by Willie Blue of SNCC,* Charleston, Mississippi, June 13, 1966. © Charmian Reading.

SNCC was founded in 1960 just as the student sit-in movement blossomed across the South. It grew out of students' realization that they needed an organizational structure to facilitate communication and coordinate the various sit-in campaigns. Resisting the calls of more established civil rights organizations—such as the National Urban League, SCLC, and NAACP—to work within existing organizations, the students struck out on their own.

From the beginning SNCC was distinctive for its focus on empowering local people and communities. Most of the major organizations paid lip service to the importance of such efforts, but the reality was that they tended to rush into a community only after local conditions created a hospitable environment for their work. The young activists of SNCC, in contrast, believed that their goal was to help create more hospitable conditions through partnerships with local residents.

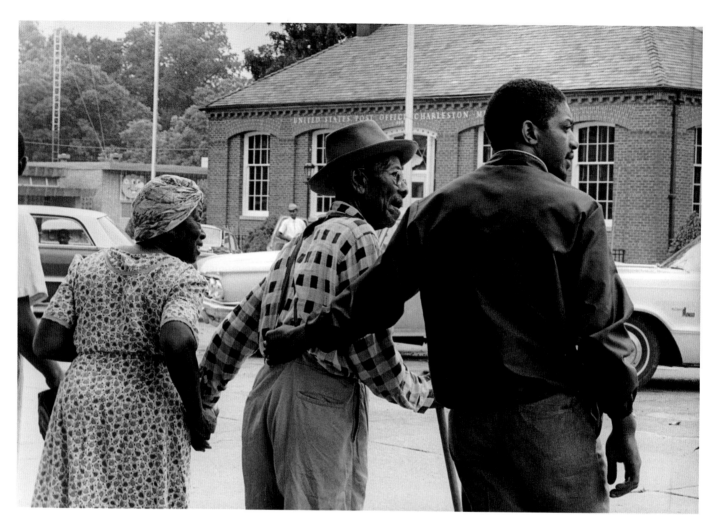

34

SNCC assigned its workers to live in communities for months or even years in an effort to support the initiatives identified as priorities by local residents. In the rural, poor, and rigidly segregated South where SNCC habitually worked, no civil rights organization was more respected by blacks and disparaged by whites.

This photograph depicts a blind sharecropper and his wife being helped across a street by Willie Blue of SNCC. Blue escorts them to the brick post office in the background, where they will register to vote in the tiny Mississippi town of Charleston. The three of them look to the right to watch for circling cars filled with armed white men intent on dissuading blacks from registering.[28] The framing of the photograph has them form a solid, protective wall across the foreground, blocking viewers from the dangers in the street. While the Voting Rights Act of 1965 had made it illegal to enforce discriminatory voting practices, white opposition to black suffrage did not evaporate with its passage, especially in smaller rural communities; it simply took on extralegal forms. In addition to facing down countless acts of physical violence, Southern blacks were at times forced to vote in general stores owned by their employers or present their marked ballots to white poll workers for review.

Blue grips the back of the husband's pants with his left hand, ensuring that he will not drift into traffic before it is safe to cross. The photograph provides a visual contrast between Blue, who is young and physically imposing, and the husband and wife, who are elderly and frail. And yet the photograph is not a study in contrasts but rather one of intergenerational cooperation. It may reference the violence that sits at the heart of canonical civil rights images, but these black figures are no longer its victims. The emphasis here is on the determination of young and old to work together in opening Mississippi to all its citizens.

35. Bob Fitch, *Septima Clark Helps a Prospective Voter Learn to Read and Write*, Camden, Alabama, 1966. © Bob Fitch/Take Stock: Images of Change.

Septima Clark was a civil rights activist before the modern civil rights movement was born. In 1919 she joined the Charleston, South Carolina, chapter of the NAACP and waged a successful campaign to force the city to hire black teachers for its segregated public schools. For the rest of her life she dedicated herself to teaching. In the mid-1950s she worked for the Highlander Folk School, an integrated adult education center in Monteagle, Tennessee, that was tarred by white politicians as a communist bastion and eventually forced to close by the state. There she was exposed to Highlander's Citizenship School, which provided teachers with an intensive training program to prepare them to lead adult education classes in their home states.

Working first under the auspices of Highland—and, after it closed, SCLC—Clark and her coworkers developed curricula and trained tens of thousands of teachers and teacher trainers. Fanning out across the South, Citizenship School teachers set up classes in churches, beauty parlors, and rural shacks to instruct illiterate blacks (and some whites) in reading and writing, voter registration, and lobbying local elected officials on behalf of their communities. Teachers trained by Clark and her colleagues began their courses by asking students to outline what they wanted to learn; subsequent sessions followed the direction set by the students. Rather than lecturing her adult learners on the importance of taking charge of their lives, she provided a learning environment that encouraged them to do so from the start. Clark taught basic literacy skills not for their own sake, but for the ways in which they changed her students' outlooks on the world. In gaining skills of literacy and registering to vote, students invariably became more civically engaged. Clark's seemingly benign project of teaching literacy cloaked a radical effort to politicize and empower blacks in the South.

This photograph illustrates Clark helping a black man form letters with his pencil in one of her Citizenship Schools in the small town of Camden, Alabama. It is removed from the

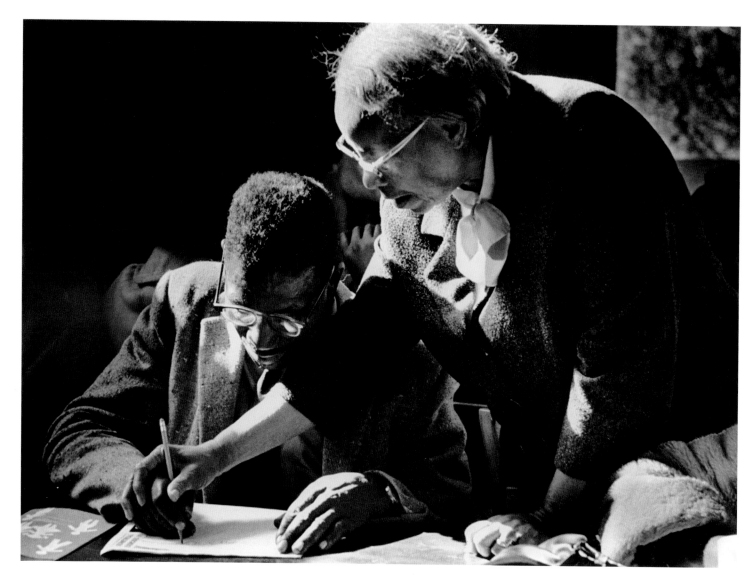

35

scenes of black voting, sit-ins, and marches because it is less obviously political. And it is removed from the famous images of the movement because it shuns confrontation and makes no particular appeal to whites. Images of police and mob violence in the South pulled on the heartstrings of well-meaning Northern whites, encouraging either their support for or acceptance of social and legislative changes. In contrast, Fitch's photograph of Clark appears to offer a simple document of the era showing two figures working intimately toward a common goal. The photograph was novel for its depiction of the civil rights struggle as a grassroots effort led by blacks. This is not a photograph created for its impact on white audiences, but one that spoke to blacks of the patient determination and work of the Citizenship School teachers and their students to change U.S. society one life at a time.

36. Bob Fitch, *Blacks Voting in Atlanta*, Atlanta, Georgia, 1966. © Bob Fitch Photo.

Black voter registration in Georgia surged after passage of the Voting Rights Act. In 1963 just 27 percent of eligible blacks were registered in the state. By 1968 that percentage had risen to 56, and blacks increasingly registered, voted, and ran for office in the decade's second half. This photograph tells that story. It shows a line of black citizens—young and old, male and female—waiting patiently for their turn in the voting booths (left foreground). These voters advance slowly toward the franchise—and symbolically approach the space occupied by viewers of the image. The photograph presents an optimistic picture of black progress through its attention to individual voters and the power of the federal government to meaningfully intervene in safeguarding voting rights; it says nothing about the ongoing efforts of white elected officials to subvert the democratic process.

Whites in Georgia vigorously and overtly resisted black franchise into the 1980s.[29] Georgia's congressional delegation took to the floor of the House of Representatives to urge defeat of the Voting Rights Act of 1965, arguing that it was unconstitutional. When the act passed and was signed into law by President Johnson, the state turned to the Supreme Court, hoping that the judiciary would overturn the legislation. Even after the court upheld the act, Georgia worked to weaken its impact by ignoring the state's obligation to get preapproval for changes in voting practices. The state adopted a number of new (and illegal) rules to tamp down black registration numbers after the implementation of the Voting Rights Act: Georgia banned neighborhood registration drives in DeKalb County, where only 24 percent of eligible black voters were registered (as compared to 81 percent of eligible whites); and the state simply refused to open additional registration sites in counties with high rates of unregistered blacks.[30]

The most famous and egregious effort of whites in Georgia to thwart the will of black voters in the aftermath of the Voting Rights Act involved the election of Julian Bond to the Georgia House of Representatives. In a special election in 1965 Bond, a founding member of SNCC, was elected in an overwhelmingly black district. This was the first election since Reconstruction in which a black American was sent to the state legislature. Shortly before the scheduled swearing-in ceremony, SNCC complicated Bond's political career by issuing a policy statement affirming its sympathy for Americans "unwilling to respond to the military draft" for Vietnam, noting the irony of asking blacks to "contribute their lives to United States aggression in Vietnam in the name of 'freedom' we find so false in this country." The statement was prompted by the recent murder of navy veteran and civil rights activist Samuel Younge Jr., who was shot by a Standard Oil gas-station attendant for trying to use a whites-only restroom. Having risked his life to uphold American values abroad, Younge died for his attempt to access equal facilities at home.

A reporter asked Bond whether or not he agreed with SNCC's statement. His response of "yes" set off a firestorm in Georgia. Southern papers and white elected officials pilloried him for his stance, arguing that his words were treasonous and that he could not be counted on to uphold his constitutional obligations as a member of Georgia's House of Representatives. At the swearing-in ceremony for new

legislators, Bond was told to step aside. Once the other elected members were sworn in, he was asked to clarify his position on the Vietnam draft under oath. Bond stood by his comments. By a vote of 187 to 12, his fellow legislators declined to seat him. As black movement leaders noted, there was something ironic about the desire of Georgia's white politicians to selectively defend the Constitution. For the previous 100 years they had shown no interest in adhering to the Fourteenth or Fifteenth Amendments, which provided for black suffrage. Undeterred, Bond ran in the special election held to fill his vacant seat and was again easily elected. The legislature again refused to seat him, and Bond was finally sworn in only after a U.S. Supreme Court ruling found that he had been improperly barred from the legislature and deprived of his right to freedom of expression.

This photograph is of a type frequently reproduced in newspapers in the aftermath of the Voting Rights Act and the momentous reforms it ushered in. While it was essential that images such as these circulated to show the black desire for the franchise and the power of legislation to change lives, they need to be set in context. Because photographs excel in communicating simple stories quickly, they frequently leave viewers with only a partial understanding of historical events. Scenes of orderly lines of black Americans from different generations waiting to vote made it appear as if the problem of race, or at least of voting, had been solved. In the later 1960s this was not the case in Georgia or anywhere else in the South.

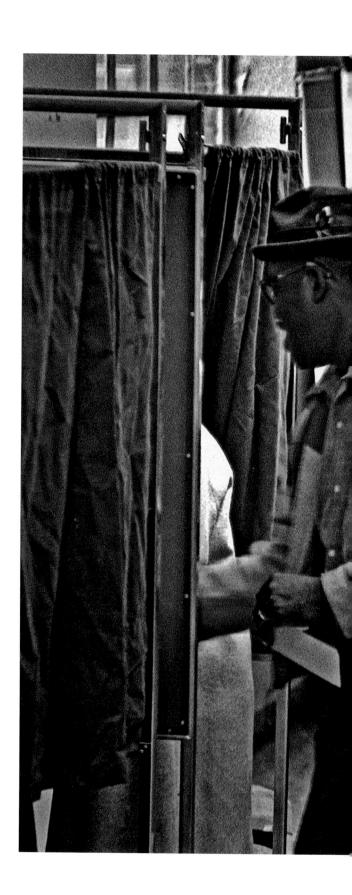

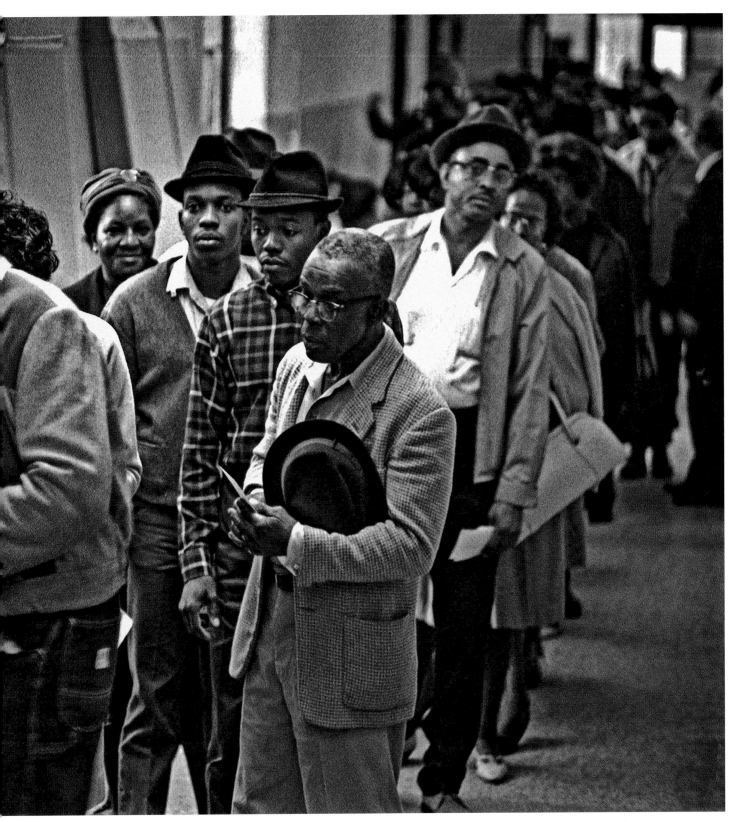

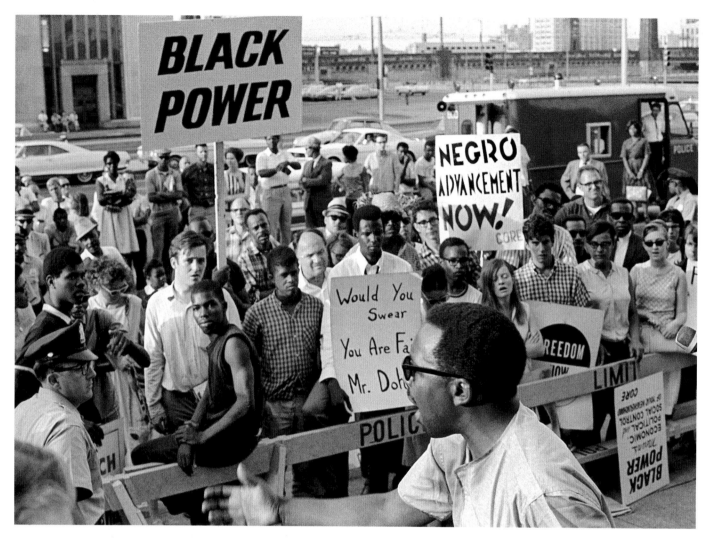

37

37. Unidentified photographer, *Listening to Their Leader*, Philadelphia, Pennsylvania, July 13, 1966. AP Images.

In the second half of the 1960s "Black Power" emerged as one of the most charged phrases in the United States. The expression came to prominence after Stokely Carmichael, chairman of SNCC, used it in a particularly fiery speech in June 1966 in Greenwood, Mississippi. The crowd was electrified. Within weeks, the phrase was embraced by the more radical elements of the civil rights movement, which, in turn, set off intense debates in the black and white press. People both inside and outside the civil rights movement debated whether it was a call for violence and black separation or simply a rallying cry for empowering black communities.

This photograph shows Bill Mathis (center foreground), the Philadelphia chapter chairman of the Congress of Racial Equality (CORE), speaking outside of the city's main post office to a crowd of young supporters. The demonstration brought together an interracial group of 300 protestors to raise awareness of discriminatory promotion practices within the post office. Mathis subsequently led activists in blocking one of the branch's entrances. He and eight other demonstrators were arrested. Displayed prominently in the foreground is a Black Power sign held aloft by a protestor; a second Black Power sign leans upside down against the police barricade. During his speech Mathis explained to supporters, "Some think 'Black Power' means violence. But the Democratic and Republican Parties have 'White Power.'. . . We just want to control the police, merchants, [and] loan companies in our community."[31]

In response to the public debate over the meaning of Black Power, *Jet* magazine published an article in July 1966 called "Black Power: What It Really Means." The article surveyed a host of civil rights leaders, ranging from moderates such as Dr. Martin Luther King Jr. to so-called militants such as Stokely Carmichael, asking each to explain the phrase to *Jet*'s readership. As the editor summed up the survey, "To too many whites, 'Black Power' means anti-white and reverse racism. But to most Negroes, 'Black Power' really means . . .

more power within the total society for black people. It is not exclusive, but rather inclusive. It attempts to organize black power in precisely the same manner that Jewish organizations have organized Jews, Irish organizations have organized Irishmen, Polish organizations have organized Poles and Italian groups have organized Italians."[32]

The *Jet* article concluded with a photograph of Mathis addressing his CORE supporters outside the post office that is nearly identical to the one reproduced here. Its caption read: "Negro and white pickets in Philadelphia support CORE's chairman William Mathis' (r) plea to end post office bias." To emphasize that Black Power was not self-evidently a threat to whites, *Jet* made a point of stressing that an integrated group of protestors attended a Black Power rally to stand with black postal workers. The photograph helps visualize both the complexity of the phrase and the ongoing possibility of interracial alliances in the later 1960s.

38. Benedict J. Fernandez, *Memphis Sanitation Strikers*, Memphis, Tennessee, April 1968. © Benedict J. Fernandez. Courtesy of Almanac Gallery, Hoboken, New Jersey.

In February 1968 more than 1,000 black sanitation workers in Memphis went out on strike. The men had a long list of grievances: They lacked a living wage, health benefits, safety equipment, and municipal recognition of their union and were particularly incensed by the city's policy of sending low-level workers home without pay during inclement weather, a practice that the city's discriminatory hiring customs ensured disproportionately harmed blacks. But the strike was catalyzed by the deaths of two black workers who were accidentally crushed by a garbage truck's compactor, which engaged unexpectedly when its wiring short-circuited in heavy rains.

The antiunion mayor of Memphis deemed the strike illegal and claimed that he would not negotiate until the men returned to work. He promised to hire replacement workers to maintain municipal sanitation services, but a lack of applicants led to mountains of garbage accumulating in the

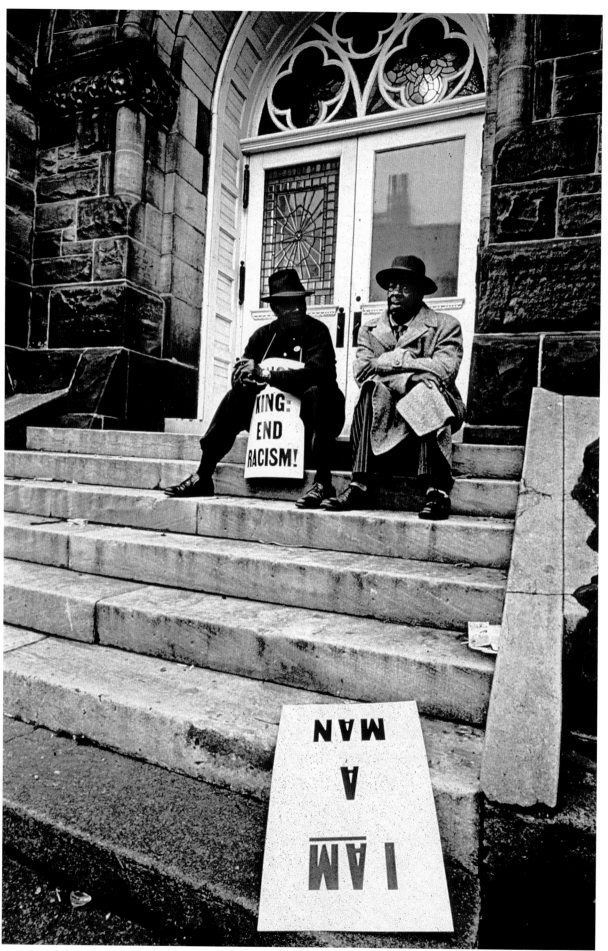

streets over the course of the nearly two-month-long strike. After police violently suppressed a peaceful demonstration by workers, black community leaders came together to form an organization dedicated to nonviolently pressing the strikers' cause. In time, local high school and college students joined the protests and helped generate essential media coverage. King was eventually persuaded to visit Memphis by the determination of the workers and their dogged focus on economic justice, a cause increasingly on his mind. It was there that he delivered his famous "Mountaintop" speech and where he would be assassinated on April 4.

The best-known photographs of the strike depict the workers wearing identical "I AM a Man" placards across their chests: one illustrates them standing in a band several men deep across a street, and others show them marching single file, parallel to a line of National Guard troops with bayonet-mounted rifles pointing toward the strikers. The poignant assertion of manhood evident in the photographs invokes the antislavery medallion designed by Josiah Wedgwood in 1787, on which was inscribed: "Am I not a man and a brother?" Photographs such as these, showing dignified men marching with identical signs, proved affecting to whites in the 1960s. And yet there is something troubling about men in the late twentieth century generating white sympathy through an assertion of identity rooted in eighteenth-century debates on the humanity of nonwhites.

This photograph shows two strikers shortly after King's assassination and a week before the strike ended. They were likely participants in the massive April 8 rally led by King's widow, Coretta Scott King, staged to ensure that both King's sacrifice and the men's cause would be remembered. The well-dressed men sit at the top of a flight of stairs. One wears a placard reading: "Honor King: End Racism!" while the other looks toward the camera with arms folded. At the foot of the stairs is a discarded "I AM a Man" sign.

By the time of King's death, many black activists and community members had lost patience with civil rights strategies designed to win over white audiences with safe pictures of black protest. King's murder led to an explosion of violence in cities around the country and gave legitimacy to more urgent calls for immediate change. The men in the photograph have apparently discarded their older, safer protest sign to embrace a new, more demanding one. Whereas they previously asserted their humanity, so leaving it to well-meaning whites to do the right thing, they now demand action. This more insistent stance would be become increasingly common in the late 1960s and 1970s, as black Americans grew impatient with the slow pace of reform.

39. John Dominis, *Black Power Salute at Olympic Games*, Mexico City, Mexico, October 16, 1968. Time-Life Pictures/Getty Images.

This is one of the most famous American photographs of the twentieth century, though it is not typically linked to the civil rights movement. It shows the U.S. sprinters Tommie Smith and John Carlos at the Mexico City Olympic Games in 1968. After placing first and third, respectively, in the men's 200-meter race, each mounted the medal stand with an "Olympic Project for Human Rights" button pinned to his track jacket, black socks displayed prominently by shoeless feet and rolled pant legs, and a single black glove. After receiving their medals, each man pivoted toward the rising flags and, as "The Star-Spangled Banner" played, raised a black-gloved fist in the air and lowered his head. The scene was captured in black and white by press photographers and in color by television cameramen and quickly circulated around the world.

At a press conference following the ceremony and in a television interview the next day with Howard Cosell, Smith patiently explained that the athletes' shoeless feet and black socks called attention to the poverty of black Americans, and that their raised gloved fists stood for both black unity and pride. Much as more traditional photographs of civil rights campaigns in locations across the South, this photograph

WOMEN

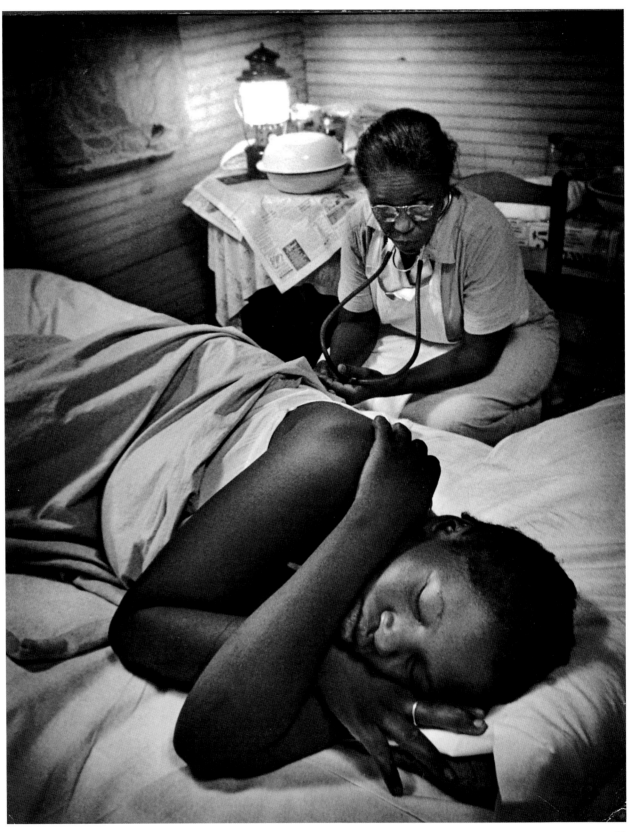

40. W. Eugene Smith, *Nurse Midwife Maude Callen Attending to a Woman in Labor*, Pineville, South Carolina, December 3, 1951. W. Eugene Smith and Time/Life Pictures/Getty Images.

Scholars conveniently date the start of the modern civil rights movement to the mid-1950s, when black Americans began to organize around the death of Emmett Till and the resistance of Rosa Parks. It is frequently noted that the movement gained impetus from the return of hundreds of thousands of black servicemen stationed abroad during World War II. These men had both fought for democracy and tasted greater freedom than they had ever known at home. They returned to the South with a new sense of what was possible. While there is little doubt that the mid-1950s saw a marked shift in the tactics and intensity of black activism, and that returning veterans were an important part of this process, there is no period in U.S. history when blacks were not working against racism and for the betterment of the poor. These were efforts in which black women have long taken leading roles.

This photographs depicts Maude Callen, a registered nurse with specialized training in public health and obstetrics, aiding Alice Cooper with the delivery of her child in a poor, mostly black rural county in South Carolina. This intimate image is taken from above, with Cooper facing us. Her body lies parallel to a back wall, framing the nurse and a small nightstand that holds a lantern that illuminates the room. Callen's specialty in obstetrics notwithstanding, she was called on to address virtually all the medical needs of her county. In addition to making daily house calls to patients dispersed over a 400-square-mile area, Callen held medical clinics in churches and school buildings, trained midwifes, and ferried seriously ill patients to the hospital in her car. Her extramedical roles included cashing relief checks for housebound patients, helping developmentally delayed and blind people with shopping, and distributing food and clothing to those most in need, sometimes at her own expense. A 1951 article in *Life* magazine, for which this photograph was commissioned, observed: "[S]he must try to be 'doctor,' dietician, psychologist, bail-goer and friend."[34]

Callen was not political in the sense of organizing voter-registration drives, but her daily work with some of the poorest and most neglected citizens in the United States represented another kind of political commitment. While she had the skills to lead a more affluent and comfortable life, she elected to work in a challenging environment, serving the most disadvantaged people in the state. When organizations such as SNCC arrived in rural communities over the next decade, they sought out leaders such as Callen to provide entry into communities and to help extend the activism of the first half of the century in new, more overtly political directions.

41. Don Cravens, *Woman Boycotting Montgomery Buses*, Montgomery, Alabama, December 1, 1955. Don Cravens and Time/Life Pictures/Getty Images.

The Montgomery Bus Boycott was rooted in decades of black frustration with the humiliating experience of using public transportation in the city. Black riders were required to pay their bus fares to the driver at the front door of the bus, then exit and reenter through the rear door to sit in seats at the back. Blacks were not only forbidden from sitting in the front of the bus, but also required to give up seats toward the rear of the vehicle if there were any white passengers standing. Noncompliance was likely to spark harassment, ejection, violence, and arrest.

The catalyst for the boycott was the arrest of Rosa Parks, who refused to give up her seat on a Montgomery bus when asked to stand to make room for a white passenger. Local black activists saw her treatment as an opportunity to simultaneously challenge segregationist laws in court and exert economic pressure on National City Lines by organizing a boycott of the 40,000 black passengers (three-quarters of them female) who made up the vast majority of the company's customer base.

The boycott is closely associated today with Parks and with the twenty-six-year-old preacher who agreed to lead the Montgomery Improvement Association, Dr. Martin

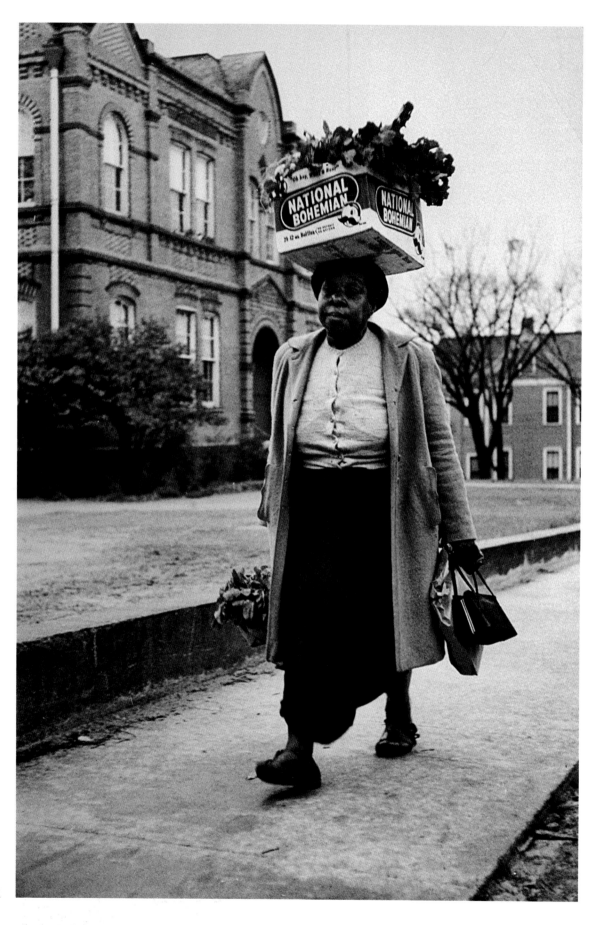

Luther King Jr. The most famous photographs of the boy-cott feature Parks riding a city bus and pensively gazing out the window or being fingerprinted by a Montgomery police officer. But while Parks and King provide the public faces of the boycott today, the boycott was initiated by the Women's Political Council and sustained by tens of thousands of local black women, most of whom labored as cooks, nannies, and housekeepers in white homes, who were willing to give up the comfort of riding to work in a bus for more than a year.

Between December 1, 1955, when the boycott began, and December 20, 1956, when the city scrapped its segregation-ist bus ordinances in response to court rulings, virtually no blacks took the city's buses. Blacks walked to work, arranged for carpools, took the taxis of supportive black drivers who charged just ten cents a ride (the cost of bus fare), or arranged for rides from white housewives who were either sympathetic to the movement or desperate not to lose their domestic help. The boycott succeeded and drew national attention because working women made great personal sacri-fices to show solidarity and stick to their principles.

This photograph shows one of the thousands of women who committed to the boycott. We see her making her way home, gripping bags in both hands and a large box of vegetables balanced solidly on her head. Don Cravens held his camera low to the ground and shot up at the women (notice how much of the underside of the National Bohemian box we see), giving the solid figure a monumental air. She holds no picket sign and makes no pronouncement to the photographer as she passes, but simply the act of walking with a heavy load makes her politics clear. Gussie Nesbitt, a fifty-three-year-old black domestic worker, surely summed up the feelings of many of the working-class women who made the boycott suc-ceed: "I wanted to cooperate with the majority of the people that . . . boycott[ed]. I wanted to be one of them that tried to make it better. I didn't want somebody else to make it better for me. I walked. I never attempted to take the bus. Never. I was tired, but I didn't have no desire to get on the bus."[35]

42. Bob Adelman, *Woman Registering to Vote*, Sumter, South Carolina, 1962. © Bob Adelman.

In 1962, when this photograph was taken, fewer than 23 percent of South Carolina's voting-age blacks were regis-tered. This was below the 29 percent average for all Southern states, but considerably better than the averages in Alabama and Mississippi. Registration in South Carolina was at least possible for blacks.

This photograph offers a tightly focused shot of an unidenti-fied middle-aged woman with pencil in hand, filling out a voter-registration form in Sumter, South Carolina. With pursed lips, the woman peers through glasses, focusing intently on the document.

It seems self-evident that black Americans went to great lengths to register to vote in the early 1960s because they wanted the opportunity to cast ballots for the candidates of their choice. But their motivations were often more complex. It is important to recall that registration only gave blacks in the South the opportunity to choose among a slate of white candidates, since blacks were then excluded from running for office. In some municipalities and states, blacks had the opportunity to vote for candidates deemed "moderate" on racial issues, but often they were left to select between candidates who were only shades apart in their commitment to racial segregation. Given the limited choices available to blacks who voted, and the often-significant price they paid for exercising this right, the decision to register often hinged on symbolic considerations. Registering and voting were impor-tant regardless of the quality of choices available because they were rights of citizenship that were both precious and rare.

But for many blacks, registering and voting were bound up in more fundamental questions of identity. One of the many small indignities that black Americans faced in com-munities across the South was the refusal of whites to use honorific titles in addressing adult men and women: "Mister," "Misses," and "Miss"—never mind "Professor" or

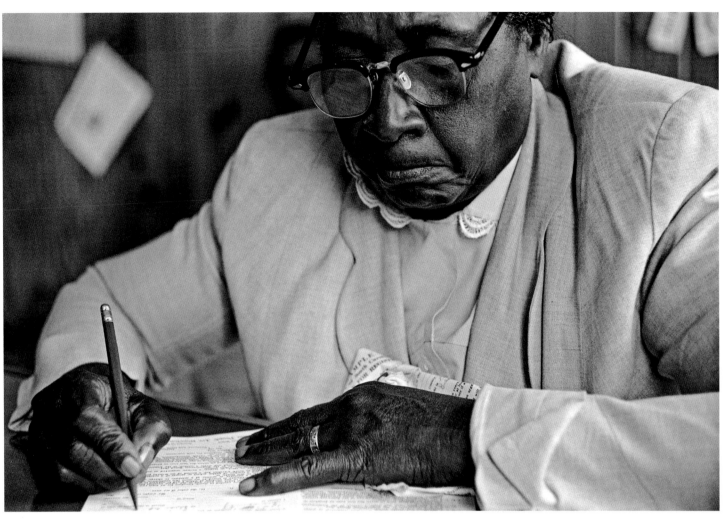

"Doctor"—were routinely dropped when whites addressed blacks. Many whites found it appropriate to address adult blacks by their first names or even to refer to them simply as "girl" or "boy." In this context, consider the pains that the pictured woman went to in dressing for her registration. She wears a light-colored jacket and blouse, the latter of which is accented with a delicately scalloped lace collar. It is a formal and comparatively expensive outfit worn to complete a task that most twenty-first century citizens consider mundane. For blacks at midcentury, voting was a sign of good citizenship that asserted their identities as women and men—as ladies and gentlemen. Photographs such as this one affirmed blacks' complex identities as responsible, refined, and determined citizens as they made the case for meaningful protection of their rights.

43. Unidentified photographer, *Woman Resisting Arrest*, Birmingham, Alabama, April 14, 1963. Courtesy of Michael Ochs Archives/Getty Images.

In the 1950s and early 1960s civil rights organizers knew the challenges they faced in convincing the millions of Americans comfortable with the social and racial status quo to accept or support significant change. Winning over whites was much less likely when protestors looked threatening. To generate white sympathy, movement leaders worked hard to ensure that activists looked and acted respectably—like "regular" Americans.

White reporters from across the political spectrum also understood this dynamic. They knew that photographs of violent or demanding black protestors were likely to inflame middle-of-the-road whites and complicate the efforts of the civil rights movement to bring change. Liberal white publications only rarely published such photographs. They largely adhered to the script established by civil rights organizations and tended to print less threatening photographs of black protest. Unsurprisingly, then, conservative white publications were much more likely to publish photographs of physically assertive or aggressive blacks, knowing that such images would

confirm their readers' impressions that black Americans were prone to violence and undeserving of equal rights.

It may surprise twenty-first-century audiences to learn that progressive black publications also published photographs of physically assertive blacks. That was the case with this photograph of an unidentified woman who vigorously resists the efforts of several Birmingham policemen to take her into custody during civil rights protests in April 1963. The photograph frames the woman's struggle as she attempts to wrest her arms away from two policemen, one of whom she appears to bite. One officer (left) has lost his sunglasses in the tussle; his left arm is a blur as he attempts to bring the woman under his control.

Versions of this photograph were published in a best-selling prosegregationist pamphlet, *The True Selma Story: Sex and Civil Rights*, in an effort to discredit the civil rights movement by suggesting that such violent behavior was typical of blacks. But versions also appeared in *Jet* magazine to support a very different point of view. In *Jet*'s caption for the photograph, the editors chastised the Birmingham police for their "rough handling" of women, before noting approvingly that one woman "went down swinging, with five cops needed to subdue her."[36] The caption questioned the propriety of police officers willing to manhandle women and applauded the struggling woman for her refusal to go quietly. For black readers of *Jet* at midcentury, there was considerable anger and frustration with the corruption, racism, and violence of public-safety officials to which black communities had long been subjected. Since few whites then read *Jet*, the editors felt able to reproduce the photograph, confident that it would not harm the reputation of the civil rights movement with white supporters and that the depiction of a woman's resistance would prove satisfying to readers who longed to see blacks exercising power and refusing to accept their assigned place.

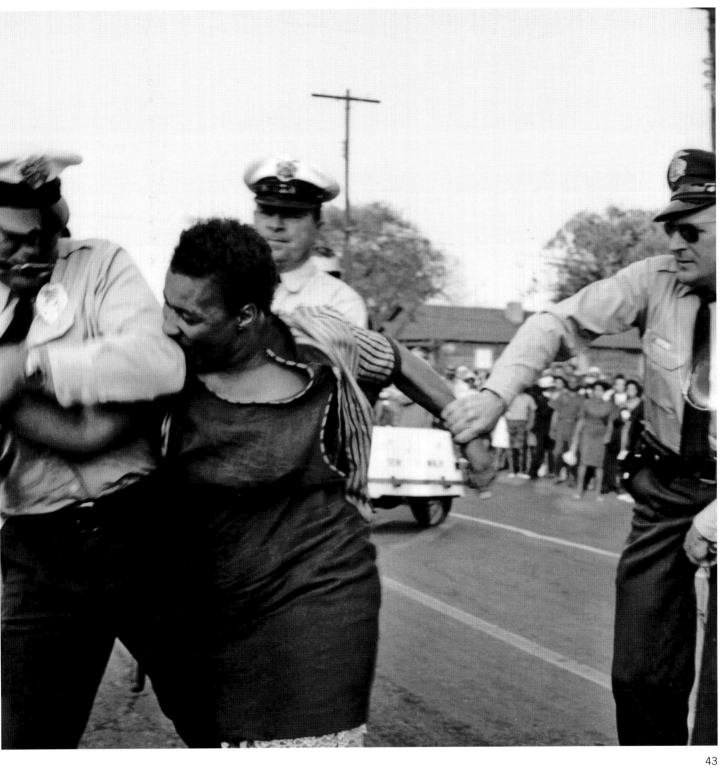

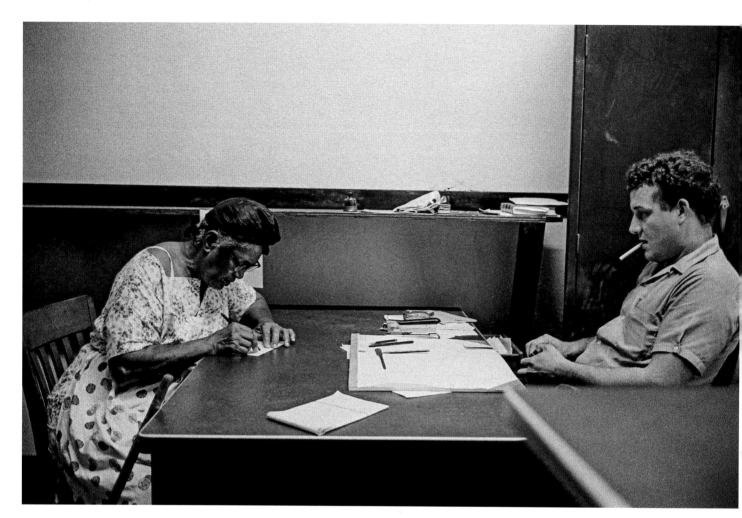

44

44. Bob Adelman, *Woman Registering to Vote in Baton Rouge, Louisiana,* 1964. © Bob Adelman.

As with most Southern states, Louisiana had a long history of placing barriers in the way of black franchise. Up until 1868 blacks were kept off voter rolls through explicit racial exclusion. At the turn of the twentieth century, white legislators adopted a state constitution that established educational and property-ownership requirements for registration but exempted through a so-called "grandfather clause" anyone registered on or before 1867 as well as their sons and grandsons. In 1921 a new state constitution implemented both an interpretation test for registration and an all-white primary.

By 1964, when this unidentified woman attempted to register, all of these requirements had been eliminated by either Congress or the courts—with the exception of the interpretation test. This test required applicants to offer "a reasonable interpretation" of a passage from either the federal or state constitution. The passage to be explicated and the evaluation of the interpretation's reasonableness were left to parish registrars. Predictably, blacks were much less likely than whites to be passed by the state's white male registrars.

This photograph provides a study in contrasts. An elderly black woman bends forward over her application form as a young white man leans back and observers her progress. It adeptly distills the battle over voting rights into a clear and legible narrative. Black determination is pitted against the prejudices of the white registrar who brings his bureaucratic powers to bear in limiting the number of blacks eligible to vote. And yet the very legibility of the photographic narrative poses a challenge for our understanding of history. Photographs that neatly emblematize the problems of race relations invariably boil the conflict down to an interpersonal struggle. While there is no doubt that actors on both sides of the conflict met and clashed in registrar offices all across the South, we need to bear in mind the structural qualities of the conflict. Photographs depicting the interactions of individual black and white figures can distract us from the larger problems of legislative, judicial, and economic systems that were arrayed against blacks who sought equal rights. The "problem" this photograph should sharpen for us is not the attitudes of the white registrar but the ways in which prejudiced beliefs were built into Louisiana society over hundreds of years through their codification in an array of discriminatory constitutional requirements, laws, and social customs. The values deeply embedded in Louisiana's laws and customs could not be overcome by the determination of individual activists—or even by the fair-mindedness of a rare registrar.

45. Charmian Reading, *Fannie Lou Hamer Singing Freedom Songs*, Mississippi, 1966. © Charmian Reading.

Fannie Lou Hamer was born into poverty, the youngest of twenty children whose parents worked as sharecroppers in rural Mississippi. She rose to become one of the most effective civil rights organizers in Mississippi and an articulate voice for change on the national stage. This photograph shows Hamer (right) with her eyes partially closed, head tilted back, and rivulets of sweat running down her face as she sings. Captured in the frame are details of three other heads, each turned in a different direction. Together the heads form a compact square.

At the age of six Hamer was tempted by a plantation owner's promise of selecting such rare delicacies as sardines, Cracker Jack, or gingerbread cookies from his commissary store if she'd consent to pick cotton for him. The overpriced goods were given to her on credit to ensure that she would remain in perpetual debt, even as she toiled daily in the fields. So began her working career. It was the standard system that trapped rural black people across the South into a lifetime of poverty. Without schools, blacks had no opportunity to select alternative vocations, and without their own land or savings, they had little chance to attain self-sufficiency or even move away. For rural blacks in Mississippi, backbreaking work might allow one to survive, but it rarely offered a route to a better life.

In 1962, when Hamer was almost forty-five years old, she attended a meeting organized by SNCC workers who sought blacks willing to risk registering for the vote. Hamer and

sixteen others agreed to try. The middle-aged volunteers traveled with SNCC workers on a rented bus to the county courthouse in Indianola, Mississippi. As they exited the bus, many of them hesitated. For black citizens, Southern courthouses, and their jails, sat at the heart of white society's authoritarian power. Wanting to register was one thing, but confronting white officials in the process was another. But as soon as Hamer descended the bus, she marched directly into the courthouse, pulling her hesitant companions in her wake.

A reluctant registrar gave Hamer the required forms, which asked, among other things, for her employer's name. This information allowed officials to notify the employer of any black who dared attempt registration. (Not only would news of Hamer's visit be known on her plantation before she returned, but she would be evicted from her home of eighteen years before the day was over.) After the forms and the literacy test, all that stood between Hamer and registration was a "citizenship understanding test." Blacks were asked to explain obscure sections of the Mississippi constitution, while whites were given basic questions to answer. As a result, almost no blacks passed, but every white did. Hamer failed her test.

On the ride back home, a policeman stopped the bus and arrested the driver. According to the officer, the bus was too yellow, making it appear to be a school bus. The bus was ordered back to Indianola, and the passengers were left to stew over their fates. As one of the SNCC workers recalled, fear began to infect the volunteers. They had shown great bravery in attempting to register, but now the state was fighting back. They had failed their tests, their driver was arrested, and they were stranded far from home. The passengers began to wonder aloud about the future. How many of their employers would confront them when they returned? Would they also be arrested? What would their family members think? And who would take care of children while they were gone? As the anxiety of the passengers rose, a voice broke the tension with a song.

Hamer launched into song to unify, calm, and inspire the group. It was a technique she would employ many times over the course of her career to celebrate a victory or comfort her allies in temporary defeat. Asked to describe Hamer's voice, the singer and civil rights activist Harry Belafonte replied,

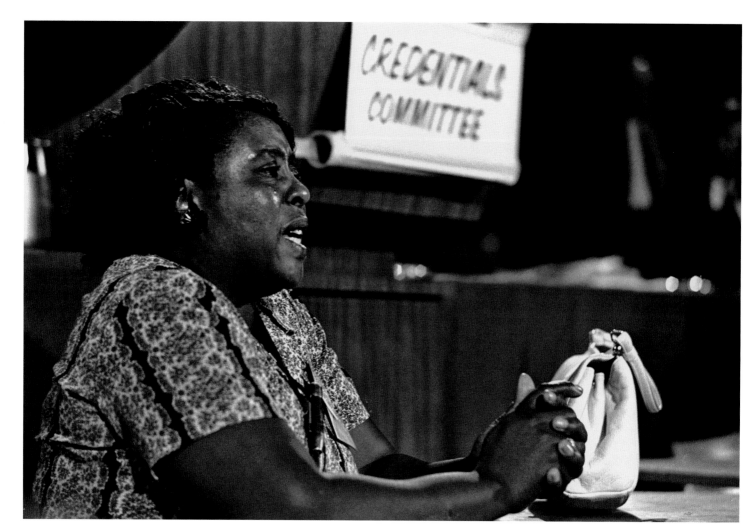

46

"I can't describe her voice—as a voice. I have got to always talk about Fannie Lou Hamer singing and the *power* of her voice because there was a mission behind it.... She felt it was needed in order to break a mood or something that was happening at the moment. That song from the heart would bring another dimension when everybody got back at the end of the song to business."[37] While song is not typically seen as a powerful tool for change, no one who spent time with Hamer held this view for long.

46. Unidentified photographer, *Fannie Lou Hamer, a Leader of the Mississippi Freedom Democratic Party, Testifies before the Credentials Committee of the Democratic National Convention in Atlantic City,* Atlantic City, New Jersey, August 22, 1964. AP Images.

In the summer of 1964 Hamer gave testimony before the credentials committee at the Democratic National Convention in Atlantic City. National television networks carried it live. This photograph shows a composed Hamer in profile, with her neat dress and dainty handbag, laying out the story of her life for the committee and detailing the ways in which Mississippi whites thwarted her constitutional right to participate in the democratic process.

Hamer arrived in Atlantic City as vice chair of the Mississippi Freedom Democratic Party (MFDP), a party that emerged from SNCC organizing efforts during the 1964 Freedom Summer. Frustrated with the slow pace of their efforts to register blacks in Mississippi and concerned that their Northern supporters in the Democratic Party tolerated a state convention that excluded blacks, the activists took their cause to a national audience. The MFDP held precinct, county, and district meetings, culminating in a state convention in the summer of 1964. There, convention delegates elected sixty-eight delegates and alternates (including four whites) to attend the Democratic National Convention in August. The MFDP would argue in Atlantic City that they—and not the all-white Mississippi delegation elected without any black participation—were the true representatives of the Democratic Party in Mississippi.

The credentials committee agreed to hear testimony from the MFDP and regular Democratic Party members to determine which of the two sets of delegates from Mississippi would be seated. Hamer was the third member of her party to testify, giving a matter-of-fact recounting of the obstructionist and often violent treatment to which she had been subject since her first effort at registering to vote. During her testimony, she recounted a particularly brutal beating inflicted on the orders of a state highway patrolman who arrested her for attending a voter-registration workshop. The officer gave a blackjack to a black male prisoner and ordered him to beat Hamer in her cell. When the man grew tired from striking Hamer, a second prisoner was ordered to continue. She concluded her testimony with: "All of this is on account we want to register, to become first-class citizens, and if the Freedom Democratic Party is not seated now, I question America. Is this America, the land of the free and the home of the brave[,] where we have to sleep with our telephones off the hooks because our lives are threatened daily because we want to live as decent human beings, in America?"[38]

Her testimony was riveting. President Johnson, watching on television, immediately understood its power to complicate his nomination. He knew that controversy would distract party officials and voters and feared that a protracted battle over seating Mississippi's delegation would alienate his white supporters in the South. In an effort to tamp down dissent, Johnson worked furiously behind the scenes to ensure that the MFDP would not be seated and even arranged to go on the air with a last-minute presidential press conference in an effort to force networks to cut away from Hamer's damaging testimony. While the MFDP did not prevail in being seated, it forced thousands of delegates in the North to take a concrete stand on the rights of black citizens in the South and exposed millions of average Americans to the realities of black life in Mississippi. For many that summer, the image of Hamer—with her respectable dress, ladylike purse, and modestly clasped hands, testifying matter-of-factly about her appalling experiences with white authorities in her home state—summed up the dignity, resolve, and righteousness of the MFDP and its goals.

encouraged them to come together to make decisions about their own lives. She believed that the poor, no matter how limited their formal education, had the ability to assess the conditions of their lives and band together with others to set the direction for the change they wished to create. While she understood that there were things she had to offer the poor, she never let go of her belief that learning went both ways—that the dispossessed had much to teach her as well.

The Democratic Party establishment in Atlantic City recognized the legitimacy of the MFDP's claims but was fearful of disturbing President Johnson's rigidly scripted convention. Hoping to broker a compromise, party officials offered the MFDP two delegate-at-large seats at the convention if the party would drop its demand to replace the regular party delegates. Democratic Party officials even went so far as to name the two people from among the MFDP delegates whom they were willing to seat. After heated internal debates, the MFDP rejected the offer, concluding that such a compromise went against its values. Since the party's claims were legitimate, as almost everyone confided to its members in private, there was no reason for it to allow the national party to exclude sixty-six of its delegates. Once the compromise was offered, many erstwhile liberal white champions of the MFDP succumbed to pressure from the White House to withdraw their support, as did many of the more established black civil rights organizations. These tactical decisions of white and black politicians infuriated Baker and the MFDP. It did not matter that the politicians claimed to have the best interests of poor blacks at heart. What mattered was that, once again, people in power were telling the blacks of Mississippi that they knew best. Such statements and actions were antithetical to what Baker spent her life trying to achieve.

If Baker had led a major civil rights organization, or if her philosophy of change had been more easily condensed into a catchy slogan, there is no doubt that she would be more widely known today for her civil rights work. Her obscurity is a direct result of her deeply held worldview that eschewed the cult of leadership and promoted a process for change rooted in the belief that the "little people" must lead the way. Baker would surely have disapproved of her portrait being elevated

into a new canon of civil rights imagery—particularly if it stood in for the thousands of lesser-known people with whom she partnered—yet her grassroots work remains worthy of remembrance.

48. Unidentified photographer, *No Entrance for Freedom Group*, Atlantic City, New Jersey, August 25, 1964. AP Images.

Once the MFDP rejected the offer of two at-large delegate seats, the Democratic Party barred the organization's members from the convention and instructed the police in Atlantic City to prevent them from entering the hall. This photograph shows MFDP delegates and their supporters (right) streaming toward the convention hall on the second day of the convention, their path blocked by police (bottom left). An NBC news cameraman (upper left) records the static face-off of protestors and police.

Fanny Lou Hamer and other members of the party would make it back inside with the help of sympathetic delegates from other states who lent their identification cards, but by then it was clear that the moral and legal challenge raised by the MFDP had been brushed aside. MFDP members were deeply disillusioned by the turn of events. This most democratic, integrated, and resolutely nonviolent group expected a long fight in its efforts to open up Mississippi's closed society, but found it disheartening to discover that its purported allies in the North were equally intransigent when MFDP demands complicated their political lives. President Johnson argued that working for his election should trump all other concerns of blacks, since his Republican opponent, Barry Goldwater, was firmly opposed to civil rights legislation. While the MFDP was nothing if not strategic in its political battles, it had none of the cynicism of the major parties. The naked political calculations and compromises made by the president, members of Congress, and Democratic Party officials were alien to a group that was deeply committed to democracy.

The events of the Democratic Party convention would push both the MFDP and SNCC in more radical directions. Each would reconsider its faith in liberal whites—and in

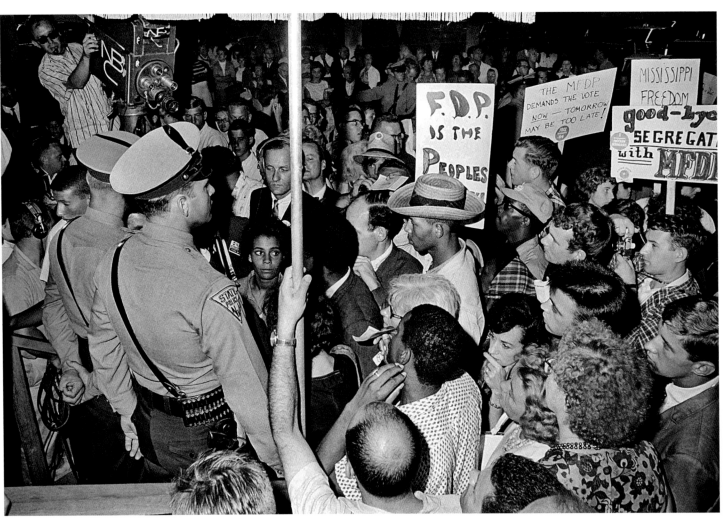

48

government more generally. More important, factions within each organization would question the efficacy of nonviolence. John Lewis, chairman of SNCC in the early 1960s, reflected years later:

> [T]his was the turning point of the civil rights movement. I'm absolutely convinced of that. Until then, despite every setback and disappointment and obstacle we had faced over the years, the belief still prevailed that the system would work.... Now for the first time, we had made our way to the very center of the system. We had played by the rules, done everything we were supposed to do, had played the game exactly as required, had arrived at the doorstep and found the door slammed in our face.... That was the turning point for the country.[39]

This photograph of the MFDP's exclusion is not particularly newsworthy. Because of the delegates' commitment to nonviolence and the restraint of the police, it offers no visual drama and no clear focus of interest. Nonviolent, grassroots approaches to forcing political change often resulted in such "boring" news images. The irony is that the failure of the party establishment to follow its own rules—never mind democratic principles—ensured that future protests would be more extreme, more violent, and hence, more newsworthy. By offering civil rights organizers a lesson in realpolitik, the establishment inadvertently coaxed black activists to create the type of visually arresting spectacles sought by the press and feared by the nation. Once a critical mass of black activists lost faith in their ability to bring change by working peacefully within the system, photographs of more extreme protest actions would come to displace such uneventful photographs.

49. Unidentified photographer, *It Rained All Day but That Did Not Dampen the Spirits of Blacks Determined to Register to Vote*, Selma, Alabama, February 17, 1965. AP Images.

White officials in Dallas County, Alabama, worked to thwart black voter registration in many ways. The county courthouse in Selma was typically open for registration only on the first and the third Mondays of each month. Blacks could

not simply register but needed to wait in line to place their names in an "appearance book," which made them theoretically eligible to come back on another first or third Monday to take literacy and "educational" tests, which were designed for failure. Adding to the difficulties, the county sheriff, Jim Clark, was fiercely opposed to black franchise. He arrested hopeful registrants who lined up outside the courthouse for blocking the entrance or sidewalk, entering through the wrong door, and frequently, just for lining up. The arrests were often carried out violently. Barriers were sufficiently high that black registration attempts in Dallas County were only sporadic in the early 1960s.

When SCLC brought a voter-registration drive to Selma in early 1965, organizers began mobilizing residents to flood the courthouse with registration requests. SCLC leaders understood the importance of presenting the Northern press with lines of orderly blacks waiting to register to make apparent the number of eager citizens who were blocked from voting. In January and February 1965, Clark arrested hundreds of protestors who did nothing more than attempt to make their way to the registrar's office. During a February 10 protest by local teenagers, Clark's men surrounded the marchers and stampeded them into a forced run. Once they were outside of the range of news reporters and camera crews, the marchers were beaten with nightsticks and shocked with electric cattle prods. On the day before the event pictured here, Clark punched an SCLC organizer in the face after he had compared Clark to Hitler. As one observer commented, it "made vivid television."[40]

This photograph is precisely the type that the SCLC wanted to see published in the Northern press. It shows an orderly and well-dressed group of women waiting patiently in a single-file line that recedes straight down the block. The women wear rain hats and coats and hold umbrellas against a steady downpour. The woman at the head of the line clutches a brown paper bag in her right hand, which is likely her lunch. Since the women knew that they would spend all day in line, they came prepared.

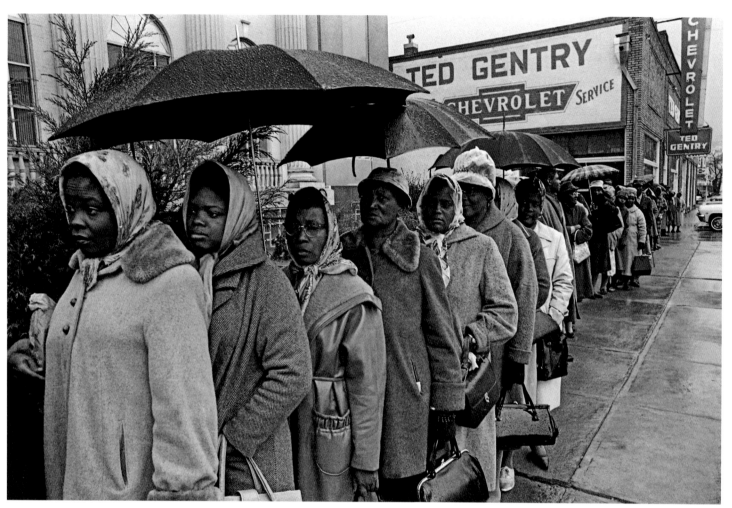

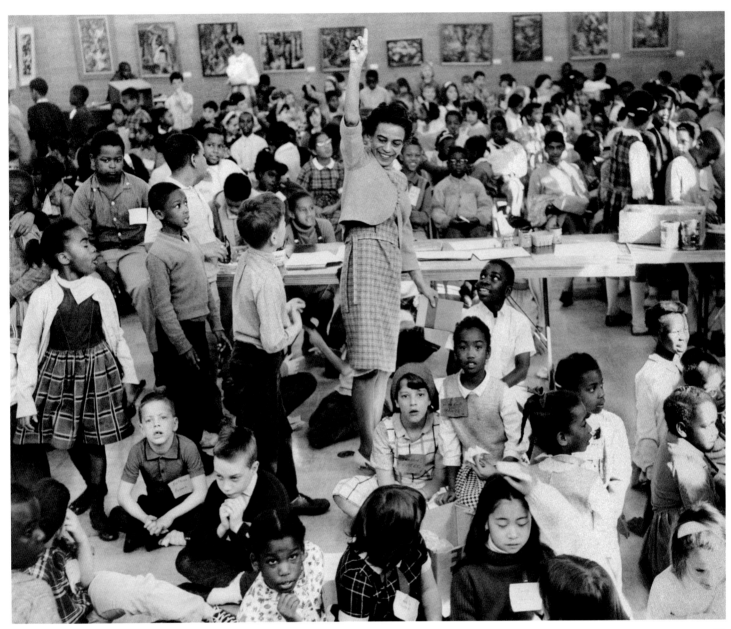

50

Standing in line was no guarantee of making it inside the courthouse. Not only was there a considerable risk of arrest and harassment, but even on days when potential regis-trants were admitted, county officials were careful to limit their numbers. These women did not line up because they expected to register that day but because they understood the need to prove to Americans outside of Alabama the genuine interest of blacks in exercising their rights as citizens. In essence, the women worked in cooperation with Northern photographers to produce nonthreatening pictures of black determination and patience in an effort to win over the sym-pathies of whites in the North.

50. Unidentified photographer, *Freedom School Filled*, Seattle, Washington, March 31, 1966. AP Images.

It is well known that blacks attacked school segregation and the inferior funding of Negro schools in many ways, princi-pally through legal challenges, protests, and lobbying. Best known today are the efforts of the NAACP, which assigned its lawyers to support the efforts of black parents to win better schooling for their children through the courts. After many decades these efforts culminated in the Supreme Court's *Brown v. Board of Education* decision of 1954, in which the court unanimously ruled that separate public schools for the races were unconstitutional.

Such national legal challenges to school segregation were slow and, as a consequence, almost never directly benefited the individual children on whose behalf the cases were first brought. By the time cases were decided, and the always-slow process of implementation begun, the children named in the suits had long since graduated. Consider that the class-action suit brought against the Board of Education in Topeka, Kansas, to integrate elementary schools, which would eventu-ally be decided in *Brown v. Board of Education*, was filed in 1951, and that the decision was not fully implemented in Topeka until 1956. By the time the city's elementary schools were integrated, Linda Brown—whose father was the "Brown" in the suit—was in high school.

This photograph illustrates a less well known, and more direct, attack on school segregation that was pointedly con-cerned with offering immediate help to students. Pictured in the center of the photograph with her arm raised is Roberta Byrd, an educator and civil rights activist who served as coprincipal of a Seattle Freedom School. She is captured speaking to an integrated group of elementary school students gathered around her in the East Madison YMCA in the spring of 1966. Freedom Schools began in the South when black activists and their white allies organized alternatives to peren-nially underfunded black schools in a pointed effort to side-step local power structures. The best-known Freedom Schools were organized in Mississippi in the summer of 1964, when thousands of young black and white volunteers worked under the auspices of the Council of Federated Organizations (COFO) to found schools across Mississippi that instructed black youths in traditional academic areas while instilling in them the value of community engagement and the ability to understand the political and racial workings of the United States.

The Seattle Freedom Schools sprang up across the city in 1966 during a two-day strike called against the city's public schools. Despite *Brown v. Board of Education*, Seattle had made little progress in desegregating its schools. The white-controlled board of education made only token efforts to dismantle a segregated school system that continued to place minority children in schools that were disproportionately black and underfunded. Activists called for sympathetic parents to keep their children out of school in protest on March 31 and April 1. To ensure that working parents would not be forced to stay home with their children during the strike, and so lose income, and to make the event educational for the students, a group of civil rights organizations arranged for volunteer teachers to staff Freedom Schools across the city. A large percentage of the parents who kept their children from school sent them to Freedom Schools to learn about African American history and the civil rights struggle.

While the schools filled primarily with black children, this photograph of Byrd makes clear that white and Asian children

attended as well. The photograph helps us see the concrete steps black activists took to make immediate changes in the educational system, points to the reality that school segregation was a problem even in progressive communities in the North, and reminds us that integration enjoyed support among some nonblack parents as well.

51. Doris Derby, *L. C. Dorsey, Civil Rights Worker from Shelby, Mississippi, at the Vegetable Cooperative*, Ruleville, Mississippi, 1968. © Doris Derby.

In 1967 two faculty members in the Tufts Medical School secured a federal grant to open a much-needed health center in Bolivar County, Mississippi. The center provided free care to indigent patients and took a comprehensive approach to tackling the numerous health problems plaguing the region's poor. The center employed local residents, created a work-study program for high school students, and in time secured a federal grant to begin the North Bolivar County Farm Cooperative.

The cooperative began by planting vegetables on several hundred acres of leased land in April 1968. Five hundred impoverished families worked the farm and were paid with a mixture of cash and vegetables. Within six months of the first planting, the resident farmers harvested more than a million pounds of vegetables, including mustard greens, collard greens, okra, onions, lima beans, black crowder, peas, and Mississippi silvers. In a 1969 article on the changing conditions for blacks in Bolivar County, *Life* magazine marveled that the farm cooperative had produced more vegetables in its first year than the previous annual output of the entire Mississippi Delta region.[41]

Doris Derby, a longtime activist and founding member of the New York branch of SNCC, took this photograph of L.C. Dorsey (standing) and her coworkers at the farm cooperative. Dorsey rose from a life of sharecropping to co-organize, and eventually lead, the cooperative. In later years, she earned a doctorate in social work and led the Delta Health Center in Mississippi. From both narrative and visual standpoints, this is not a dramatic photograph. It does not illustrate a spectacular scene of confrontation or of lofty oration; instead it shows Dorsey and two seated women staffing a farm cooperative table, surrounded by baskets of produce. But this ordinary photograph, documenting the distribution of vegetables, points to an important aspect of black empowerment in the later 1960s. Given a shoestring budget, Dorsey and her coworkers put together an effective cooperative that employed hundreds of people, provided high-quality produce to thousands more, and served as a model of black self-sufficiency in a region where the opportunities for blacks were severely limited. Photographs of such everyday scenes show the heroism of women overcoming long odds to improve the daily lives and prospects of thousands of blacks.

CHILDREN AND YOUTHS

52. Unidentified photographer, *An Unidentified Black Student Attends Class at Clinton High*, Clinton, Tennessee, August 31, 1956. AP Images.

Before 1956 black high school students in the small community of Clinton, Tennessee, were bused miles outside of town to keep the city's high school restricted to whites. Each morning black students left home at 6:30 to walk past all-white Clinton High School on their way to a bus that would take them on a two-hour drive to school.

Clinton was in many ways an ideal community in which to begin the desegregation of Tennessee's public schools. Not only did it have a tiny black population, making the prospect of integrating its high school appear less threatening to local white parents, but it had a principal, teachers, school board, and even a majority of white parents who accepted the coming of integration. Once the governor made it clear that he deemed the issue best dealt with at the local level, the school board decided to proceed with integrating Clinton High in the fall of 1956.

On August 27, 1956, twelve black students, who came to be known as the "Clinton 12," entered Clinton High on the first day of the new school year. Five lonely demonstrators outside the school protested the presence of black students, but the day went smoothly. Buoyed by a calm first day, many in the community hoped that tensions would now subside. Within days, however, Clinton would be in the national news, not for the smoothness of its integration efforts but for the violence of the antiblack backlash. The countermovement was led by Frederick John Kasper, a defender of segregation and leader of the local White Citizens' Council, a powerful organization that had sprung up in the post–*Brown v. Board of Education* era to preserve the privilege of whites in the South. Kasper organized enormous demonstrations outside of Clinton

High, which only grew in size and violence as press coverage expanded. On September 1 more than 4,000 protestors descended on a town of some 5,000 residents to hear Kasper speak at the courthouse. The rally turned violent and was brought under control only with the arrival of more than 100 state troopers, who were reinforced the next day by Tennessee National Guardsmen. Over the following months the black community was terrorized by threats shouted on the street and delivered in anonymous telephone calls, gunshots fired into homes, a series of bombings, and a robed Ku Klux Klan rally held on the town square.

That was the context in which this unidentified black student attended class at Clinton High. The photographer shot through the darkened doorframe of the classroom, giving the impression that viewers have gained access to a hidden world. The black girl sits toward the back of the room, near the exit, with a wide swath of empty chairs surrounding her. Her white classmates, most of whom were willing to tolerate integration, did little to make her feel at home and gave her and the other black students a wide berth. Despite the fierce pressure exerted on black students by violence and its threat in the community, and notwithstanding the cool reception that greeted the students inside the school, seven of the twelve students persevered that first year. When mainstream news outlets covered the integration efforts in Clinton, they tended to focus on the actions of white rioters, judges, and law-enforcement officers. *Life*, for example, devoted most of its photographs and text to the white instigator of the conflict, the principal who opposed him, and the judges who tried to maintain order. A December article focused its coverage on a "brave" white minister who volunteered to walk black students to school.[42] This photograph testifies to the lonely, daily struggles black students faced among supposedly accommodating white peers, away from the street battles and court clashes that so animated accounts in the white press.

53. Unidentified photographer, *Lunch Counter Protest in North Carolina,* Raleigh, North Carolina, February 10, 1960. © Bettmann/Corbis.

The sit-in photographs that are best known today show moments of high drama, often with flashes of violence. Typical scenes illustrate white crowds threatening peaceful protestors before dousing them with coffee and condiments and, at times, burning them with cigarettes. Some of the photographs show the chaos that ensued when white mobs chose to pull protestors from their stools and beat them on the floor.

This photograph shows two well-dressed black youths sitting at a nearly empty lunch counter poring over books as two white waitresses sit across from them surveying the scene.

The student at the center of the photograph positioned himself before a large slice of triple-layer cake that sits under a glass cover, tantalizingly out of reach. The sit-ins in Raleigh were not the most famous of those inspired by the student protests in Greensboro, but this photograph nonetheless illustrates an important feature of the sit-ins. While photographs depicting dramatic confrontations were more likely to be published in the press, they captured but one facet of lunch-counter protests that were often much more mundane.

Students would arrive at lunch counters early in the day and were prepared to wait. When service was denied, they would spend their time trying to engage white patrons or store employees in conversation. If that failed, they would turn to their homework, sometimes even after workers turned

off the lights. The point of the protests was to visualize (and articulate) the absurdity of turning away paying black and white customers merely because they were willing to eat side by side. Protestors understood that change would come not only from bad publicity over the department stores' policies, but also from the loss of business that neither national nor regional stores could sustain for long. Managers would commonly close lunch counters once black demonstrators showed up, ensuring that the seats occupied by protestors would not generate income and the entire lunch counter would forfeit a day's worth of sales. Thus it was essential that the students remained on their stools, particularly when they were *not* harassed, to make sure that the store suffered the greatest possible financial loss. Such uneventful, lackluster protests— and the photographs that resulted—were not newsworthy, though they remain important for demonstrating the day-in, day-out commitment of young protestors, which was essential for advancing their cause.

54. Unidentified photographer, *Dion Diamond, a Student at Howard University in Washington, DC, Is Surrounded by White Youths during a Sit-In Demonstration*, Arlington, Virginia, June 9, 1960. AP Images.

Dion Diamond was a founding member of Howard University's Nonviolent Action Group (NAG), a student-run organization that fought against segregation and for black civil rights. He would go on to become a Freedom Rider in 1961 and to serve as SNCC field secretary in Louisiana and Mississippi in 1962–63.

This photograph captures Diamond at a NAG-sponsored lunch-counter sit-in just days before his nineteenth birthday. Over his shoulder we glimpse fellow sit-in participants (left) and a semicircle filled with a mix of curious and disapproving white men and boys (right). Diamond looks calmly at a youthful member of the crowd who emphasizes a point emphatically with his index finger extended.

Sit-ins worked on multiple levels. They drew media attention for their novelty and for the often-striking scenes of conflict they generated, and they simultaneously put economic pressure on the individual department stores through the loss of paying customers. In the spirit of protests first pioneered in the United States by CORE in the 1940s, the sit-ins of the 1960s also attempted to change the minds of the locals who came in contact with demonstrators. James Lawson, field secretary of the Fellowship of Reconciliation, was instrumental in training the students who waged the famous Nashville sit-ins. As he explained, the sit-in protestors "were supposed to sit, ask for service, and if it didn't come—which of course it didn't—then talk with customers around them, and talk with the waiter, waitresses, see what attitudes were, and then ask to see the manager or somebody in authority and talk with them about the policy of the place."[43]

We see Diamond engaging with the crowd that surrounds him, trying to hear their points of view and, no doubt, articulate to them the perspective of the protestors. In an era when stores, restaurants, and workplaces were vastly more segregated than they are today, and when mainstream newspapers and television stations rarely presented the perspectives of nonwhites, this dialogue was likely one of the rare moments when a white crowd could hear the unfiltered views of a civil rights activist. Diamond and his companions were under no illusions as to their ability to sway angry white crowds, but they knew that the nonviolent protests to which they were committed could succeed only to the degree that their opponents' views would change over time. The encounter pictured here was not going to alter U.S. society by itself, though it did represent the kind of dialogue that has always been the foundation of peaceful, far-reaching change.

56

unequally applied, and entailed significant consequences. The child protestors arrested in Birmingham paid a heavy price for their activism. Many were physically abused, and all were fingerprinted, photographed, and thrown in jail. Most begged their parents to refrain from paying their bail and, as a consequence, spent days in jail. After their release, they were threatened with expulsion from school (a threat ultimately blocked by the courts), forced to pay court-imposed fines, and marked with criminal records.

Black parents anguished over the decision of whether or not to grant permission to children who wished to participate in illegal street demonstrations. On the one hand, they knew that the participation of children was more likely to get coverage in the white press and so draw attention to the cause. They also understood that children were freer to participate in protests, since unlike adults, they were less likely to have jobs from which they could be fired for their activism. On the other hand, parents were terrified of the physical violence, including rape, that children suffered at the hands of police and worried about future educational and employment prospects for those children saddled with criminal records.

We know from the testimony of child protestors that while some joined the protests after securing reluctant assent from their parents, others simply stole away from school without informing parents or teachers of their plans. There are also cases where parents were proud to support the decision of their children to take a stand for justice, knowing that their ability to shield their children from the racism of Jim Crow society was limited. In many cases, parents ultimately concluded that their children's participation made sense, given that young people had the greatest stake in transforming U.S. society.

This photograph shows children taken into custody by policemen in Birmingham, Alabama, during the Children's Crusade. Child protestors were arrested, variously, for parading without a permit or trespassing after warning. The neatly dressed kids march calmly toward rented school buses that will transport them to booking centers and detention facilities. Despite their youth, they are not crying for parents but walking calmly in an orderly line. If the photograph offers testimony on the

determination of the city's black children, it also tells us much about the outlook of the white authorities. The public safety commissioner, Bull Connor, was so invested in preserving his authority over blacks and maintaining the city's segregationist ordinances that he deemed even young children a threat. Connor treated young black protestors exactly as he treated their parents. His ruthless consistency brought sympathy to movement participants and even helped some whites in the South to see the absurdity of the segregationist battle. As one Birmingham police officer commented to his captain as bus after bus of arrested children was loaded, "[T]en or fifteen years from now, we will look back on this and we will say, 'How stupid can you be?'"[46]

Photographs such as this one were not published by mainstream news outlets in the South, which did their best to avoid all coverage of civil rights protests, and were reproduced only sparingly in the Northern white press, which may have found images of children arrested by white policemen too embarrassing. This lack of circulation was unfortunate. Just as observing events in Birmingham made the aforementioned white officer grapple with the absurdity of arresting children to enforce segregationist laws, so circulation of the scenes in photographs could have had a similar impact on millions of whites, hastening the arrival of the day when they asked, "How stupid can you be?"

57. Unidentified photographer, *Six Blacks Arrested for Parading without a Permit*, Jackson, Mississippi, June 3, 1963. AP Images.

This photograph captures a small group of protestors during a tumultuous time in Jackson, Mississippi: in the middle of a damaging black boycott of downtown stores; a week after the famed Woolworth's sit-ins; days after student-led protests ended with the arrest of some 600 young people; during a period in which white segregationists shot randomly into black neighborhoods, homes, and the local Tougaloo College; and days before the city obtained a county court injunction barring blacks from participating in such "unlawful" actions

as street parades, processions, demonstrations, boycotts, trespass, and picketing. It was an environment that scared away most adult black activists but which left the young people who led protests in Jackson undaunted.

Three young female protestors sit on a curb with their hands behind their necks. They face a waiting paddy wagon and the downtown stores that were then the object of a large black consumer boycott. Black trustees (center), working on orders of the police, carry a male protestor to a waiting paddy wagon. A helmeted officer (right foreground) holds several confiscated protest signs and U.S. flags as he observes the scene.

Black civil rights demonstrators often marched with both protest signs and U.S. flags. The signs reduced their demands to pithy slogans aimed at capturing the attention of local and national audiences. Typical messages read "Freedom Now," "End Segregation," and "Equal Rights Now." The flags served a more complex function. Protestors hoped that the Stars and Stripes would communicate their identity as Americans and, hence, the legitimacy of their demands for integration, freedom, and equal rights. The flags were also efforts to balance the obvious criticisms leveled in the protest signs against U.S. society. They helped affirm that the protestors embraced America, even as they demanded its reform.

Whites in the South often found it infuriating when blacks marched with U.S. flags. There were several likely causes of this anger. Whites who rallied in support of segregation frequently carried flags from the former Confederate States of America in an effort to make their racial politics clear. Thus, blacks' use of the U.S. flag may have unsettled Southern whites by suggesting that blacks were more patriotic, more American. Given the common white association of blacks with un-Americanness, this was not a trivial matter. The supposed un-Americanness of blacks was rooted, most obviously, in their protest against the status quo. In a society that prized conformity, any push for change made would-be reformers appear as unpatriotic. The national identity of blacks was also suspect because of the particular causes they championed. At that time, both integration and economic opportunity were linked in the minds of mainstream whites to communism,

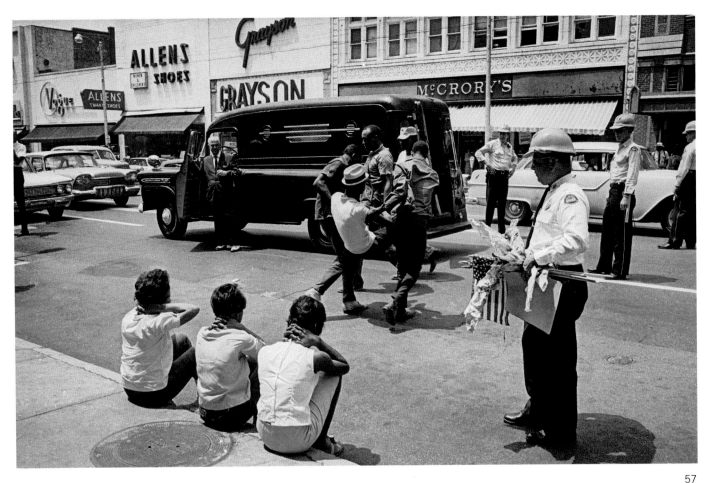

57

which was the paradigmatically un-American social system. And most important, blacks were labeled un-American because of their race. There was a disjunction between white Americans' intellectual understanding that blacks were U.S. citizens and their intuitive sense that their values, beliefs, behaviors, and even biology made them fundamentally different. Whites of the era unselfconsciously equated Americanness with whiteness, making blacks' use of the flag a challenge to the definition of the country rather than benign evidence of their belonging.

The events and attitudes captured in civil rights photographs will strike many viewers today as relics from a distant past. Even as we acknowledge the lingering problems of race that haunt U.S. society, the graphic scenes of brutality and racism

that were a staple of the 1960s seem far removed from contemporary society. And yet, civil rights photographs have as much to teach us about the present as the past. Consider that social scientists have amassed considerable evidence that whites of our own time continue to perceive a link between Americanness and whiteness. While few whites today are consciously aware of this association, empirical studies reveal that they continue to act as if the connection exists. While this fifty-year-old black-and-white scene of arrests in Jackson is dated in many ways, it nonetheless retains important ties to the racial issues of our day.[47]

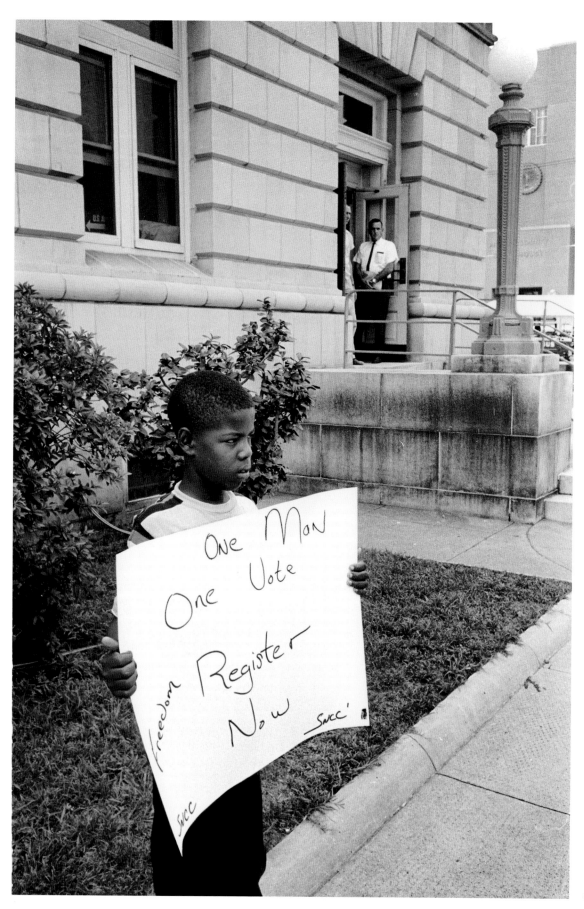

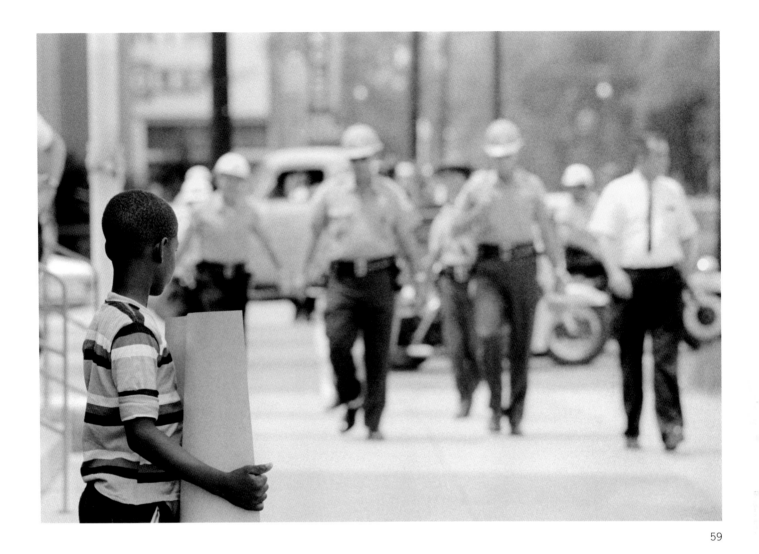

59

58. Matt Herron, *Child Demonstrates Alone in front of the Dallas County Courthouse,* Selma, Alabama, July 8, 1964. © Matt Herron.

59. Matt Herron, *Deputies Approach Child Demonstrator in front of the Dallas County Courthouse,* Selma, Alabama, July 8, 1964. © Matt Herron.

Six days after President Johnson signed the Civil Rights Act into law in July 1964, SNCC held a protest outside of the Dallas County courthouse in Selma, Alabama, to encourage black voter registration. Title I of the act barred the unequal application of voter-registration requirements, making it illegal for counties to set different requirements for different races. Since it did not set federal standards for such requirements or prohibit them altogether—as would the 1965 Voting Rights Act—it did nothing to curb the use of literacy and "educational" tests that were patently unfair to blacks. Such tests excluded many blacks who by design had received inferior educations in segregated and chronically underfunded public schools. And nothing in the act prevented the unequal grading of tests taken by blacks and whites. As long as the tests were given to all who wished to register, there was no mechanism for standardizing the subjective evaluations of the all-white Southern registrars who consistently failed blacks and passed whites.

These two photographs are sequential shots illustrating a protest staged by eight-year-old Samuel Newall outside the Dallas County courthouse. He stands alone near the courthouse steps holding a hand-lettered sign reading: "One Man, One Vote. Register Now." Also printed across the sign is the word "Freedom" and "SNCC." In the first photograph two whites who flank the entryway to the courthouse observe him. In the second photograph Newall is approached by a scrum of helmeted law-enforcement officers who tower above him. They are moments away from confiscating his sign, placing him under arrest, and marching him to jail.

The images demonstrate the bravery of Newall and the hysteria of local law-enforcement officials, who were sufficiently threatened by a child and his homemade sign that they felt obligated to make an arrest. But the images are also important for what they reveal of the changing attitude of black activists in the mid-1960s. Notice that Newall's protest sign is not directed at county officials. He does not ask whites to allow black voting or even to dismantle discriminatory registration procedures. Instead, he directs his message to blacks, urging them to act. "Register Now" is his message. SNCC appreciated that whites needed to change both their attitudes and laws, but its focus was foremost on empowering blacks. While older models of black activism, pioneered by such organizations as the NAACP, counted on white judges and politicians doing the right things in time, SNCC was more concerned with building power in the black community. The boy's sign may have proven particularly galling to Selma's whites because it failed to acknowledge their power. In bypassing whites and speaking directly to blacks, Newall telegraphed an indifference to the hierarchy of power in the South. It was a challenge that police felt compelled to address.

60. Unidentified photographer, *Valerie Banks Was the Only Student to Show Up for Her Geography Class at South Boston High School on the First Day of Court-Ordered Busing to Desegregate Boston's Schools,* **Boston, Massachusetts, September 12, 1974. AP Images.**

In a landmark court decision in 1974, District Court Judge Wendell Arthur Garrity found that Boston's public schools were unconstitutionally segregated by race. Whereas school segregation in the South had been a product of laws, Boston's was produced by policy decisions made by the city's school committee and patterns of residential segregation. In an effort to remedy the problem, Garrity ordered the implementation of a busing plan drawn up by the State Board of Education for all municipal schools that were more than 50 percent white. The plan bused large numbers of white children outside their neighborhoods to predominantly black schools and black children to schools that were predominantly white. His mandated solution to school segregation, and its more than decade-long implementation and refinement, drew swift and, at times, violent reactions from a diehard group of white working-class parents who objected to the court's interference in their lives.

The busing battle in Boston was marked by threats against Judge Garrity, parent-led school boycotts, marches, demonstrations, and riots—and much harassment and violence directed against the students bused to new schools. The ensuing chaos, particularly in the South Boston and Charlestown neighborhoods, was well covered by the press and helped drive down public school attendance in the city.

At the start, the press was generally supportive of desegregation efforts and tended to brand as racist the white parents who resisted. While the court ruling undoubtedly catalyzed an ugly and violent antiblack backlash, a focus on racist working-class whites obscured the deeper problems inherent in the segregated North of the 1970s. An earlier Supreme Court ruling constrained Judge Garrity's options by barring a judicial solution to segregated schools that extended beyond the confines of the city proper. Because Garrity was unable to include the greater metropolitan region in his desegregation plan, and given the extensive middle-class white flight to

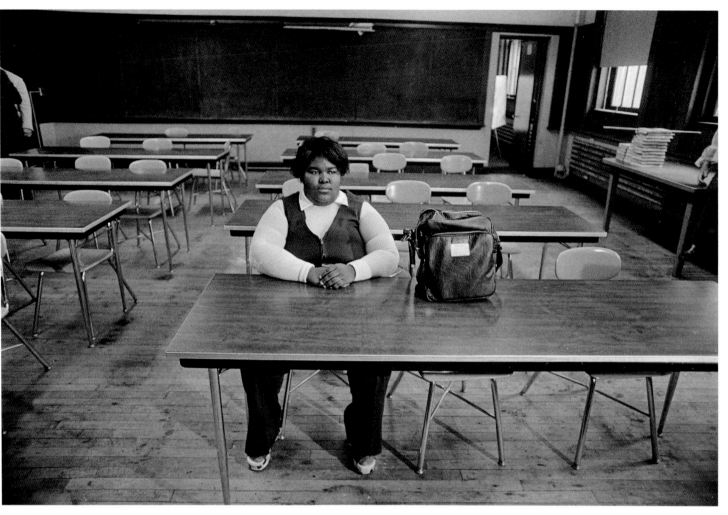

the suburbs that had occurred over the previous decades, his order primarily affected low-income city dwellers—both white and black. Since middle-class whites lived overwhelmingly in white suburbs, where their children enrolled in all-white schools unaffected by the court order, it was comparatively easy for them to burnish their liberal credentials by demonizing as "racist" those inner-city whites who resisted busing. Suburban whites never confronted the prospect of their children suffering the dislocation and anxiety of being sent to distant, unfamiliar schools at a moment of keen social conflict. Safely ensconced in the suburbs, they had little incentive to consider their own complicity in segregated housing patterns, school-funding formulas, banks' redlining policies, and suburban highway spending allocations that kept their neighborhoods white.

This photograph shows Valerie Banks, who was bused to the predominantly white South Boston High School, on the first day of the court-ordered desegregation plan. It is a type of photograph that circulated widely in the liberal white press in the early 1970s to paint a sympathetic picture of black children and the busing experiment. It shows the dedication of Banks and her parents to education, given that she attended school during a tense time of boycotts, marches, and potential violence. It also offered a subtle criticism of the many white parents who kept their children away. At a time when the "threat" of black male students mixing with innocent white schoolgirls raised fears of rape and miscegenation among some white parents, Banks presents a disarming picture of integration. It is hard to imagine the threat posed by this composed young woman who waits quietly at the front of the class.

In the 1970s photographs of lone, black high school students in classrooms spoke to white Americans about the character of the pictured students. The lessons of such photographs appeared self-evidently contained in their narratives. With the addition of more background information on the racial politics of the era, such images can help audiences today grapple with larger, systemic problems and see how photographic narratives of lone black students played a role in obscuring the culpability of wealthy suburban whites in perpetuating the very systems of segregation they blamed on the city's less affluent European Americans.

JOY

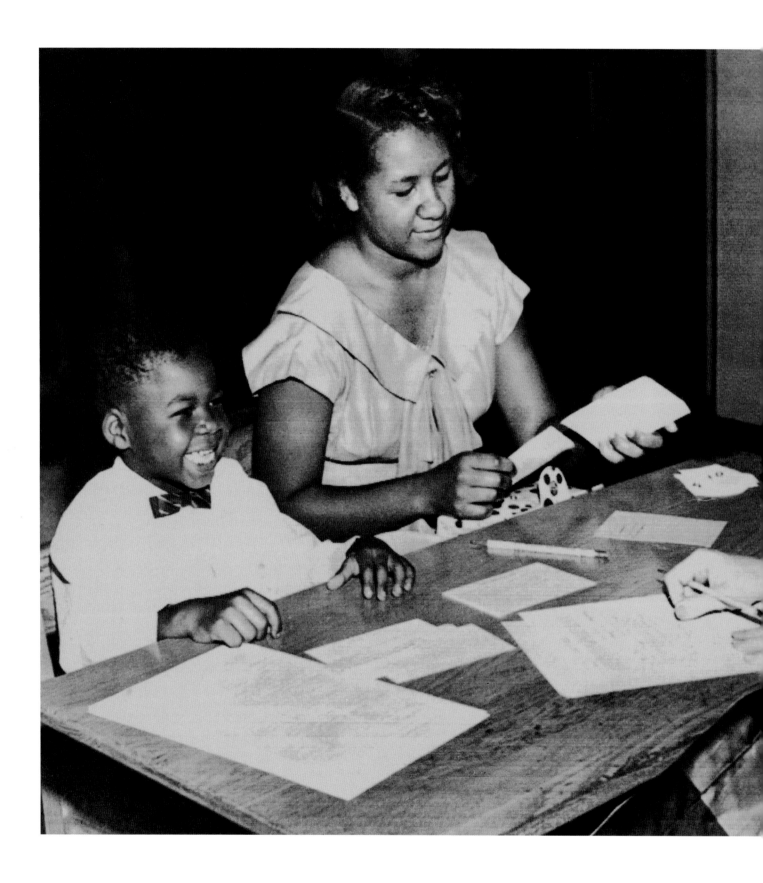

61

61. Unidentified photographer, *A Smile for Teacher*, Nashville, Tennessee, August 27, 1957. AP Images.

When we think about the desegregation of public schools, images of unrest surely come to mind. While it is true that many integrating schools were the sites of violent segregationist rallies and that many thousands of black students who integrated the first schools faced a hostile reception at the hands of their white peers, there are many other stories to be told.

Nashville began the integration its public schools comparatively early—three years after the 1954 *Brown v. Board of Education* Supreme Court decision found the segregation of public school students unconstitutional. During a period when many Southern elected officials worked to thwart integration in public schools (most famously in Arkansas, Alabama, Virginia, and Texas), white leaders in Tennessee took a more progressive approach. In the summer of 1957 the city implemented a "stairstep plan" that saw nineteen preselected black first graders enroll in eight previously segregated schools. The plan called for the desegregation of one grade per year, ending with the integration of the twelfth grade in 1968.

This photograph shows a smiling young Marvin Moore, age six, with a dapper bow tie, seated beside his mother, Maude Baxter. They sit at the far side of a desk across from Mrs. Louis Miller, a teacher in the all-white Glenn School, who helps register the boy for school. While mother and teacher are surely conscious of the potential for conflict during the upcoming year, the boy shows no signs of anxiety at the prospect of attending his new school. One of the narratives that is often lost in the photographic representation of public-school integration is black students' hunger for learning. Integrated schools offered the promise of better facilities, equipment, and textbooks. Moore appears to show unselfconscious elation at the prospect of starting at his new school, even as the two women present themselves to the news photographer with more restrained expressions of emotion.

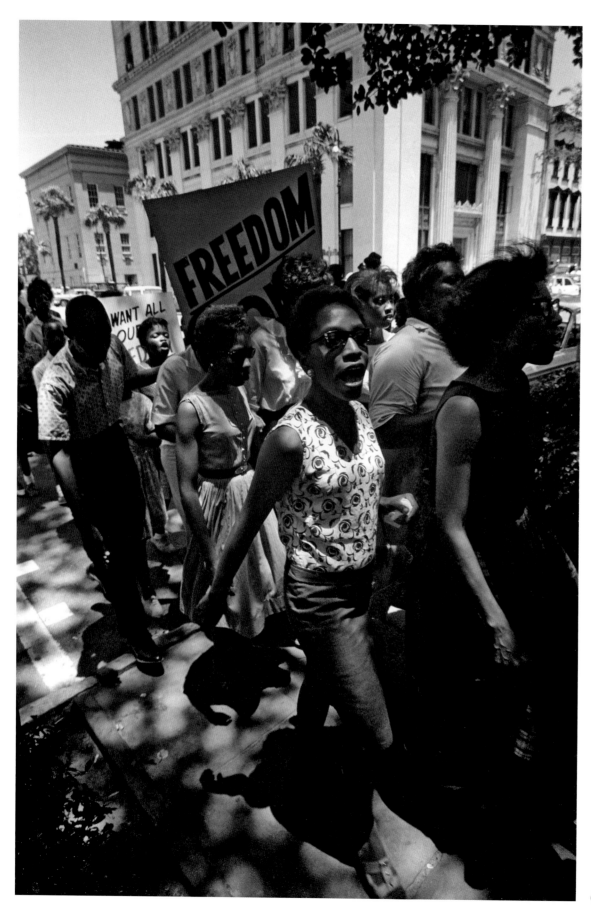

62. Frederick C. Baldwin, *Singing Freedom Songs*, Savannah, Georgia, 1963. © Frederick C. Baldwin.

The photographic record of the civil rights movement is a largely sober affair of orderly protestors marching and praying with solemn determination. The reality for most black participants was starkly different. Protestors came together in joy, excited at the prospect of taking action to change U.S. society and also energized by the act of joining into a like-minded group of citizens. Music and song permeated the movement's activities, serving as a vital component of change and celebration. This photograph shows a diagonal line of black demonstrators united in song as they march along a sidewalk in downtown Savannah. A partially visible sign reads "FREEDOM NOW." Dappled light frames a central female figure as she sings and marches.

Song allowed black civil rights activists to both dull and sharpen the threat of change for whites. Since many of the songs of the movement were traditional Negro spirituals, they cloaked calls for change in the familiar metaphors of biblical narratives. For even the most die-hard segregationist, there was comfort and familiarity in spirituals, which were seen as an appropriate part of black culture, reaching back as they did to the era of slavery. As a host of scholars have argued, songs about the deliverance of the Israelites from Egypt, for example, not only piously referenced the Old Testament but also subversively nodded to the desire of black listeners for an escape from Jim Crow society in the present. Negro spirituals held distinct meanings for different audiences.[48]

Activists sharpened their messages of change by pairing older melodies with new lyrics, updated to address the conflicts of the moment. Protestors were known to praise and cajole President Kennedy and, later, President Johnson, in song and to invent lyrics that poked fun at such intractable civil rights foes as Alabama Governor George C. Wallace, Dallas County Sheriff Jim Clark, Birmingham Public Safety Commissioner Bull Connor, and Mississippi Governor Ross Barnett.

A year before the protest march pictured here, an editorial in the influential black-owned *Chicago Daily Defender* celebrated the vital role of songs to the civil rights movement. It began with a historical survey, noting that "from the days of slavery to the present 'sit-ins,' Negroes have been singing of a promised land, always hoping that one day, someday, things would get better in the sweet bye and bye." But as the editors made clear, song in the modern movement did not offer spiritual consolation for blacks who had to wait for deliverance to the Promised Land. The *Defender* claimed that blacks in the 1960s were "not thinking about pie in the sky, in the sweet bye and bye, but a piece of that pie, now." The editorial went on to note, "[N]o longer are the young singing: 'Gwine to sit at the welcome table,' but 'I'm going to sit at the white man's table.'"[49]

63. Bob Adelman, *Picketer Under Arrest behind Loveman's Department Store*, Birmingham, Alabama, April or May 1963. © Bob Adelman.

When national civil rights organizations considered where to initiate new campaigns, they did not simply look for stark examples of injustice. Leaders were practical. Knowing that successful campaigns were built on the bedrock of black community support and that motivating large numbers of people to march, register to vote, boycott, or protest was difficult, they always carefully considered the attitudes of local communities before committing to a new campaign.

In virtually every black community, organizers could be assured of a handful of committed local activists. But to gather the masses of people needed for an effective campaign, protest leaders had to help move people beyond the fear produced by centuries of mistreatment by their white compatriots. Blacks in the South had good reason to dread the courts, state legislators, and, particularly, police and sheriff departments. It was not simply their knowledge of historical mistreatment but continuing daily examples of black activists harassed, fired, assaulted, or killed for their political work that made the costs of involvement real. On top of their fear of white authorities was sometimes a wariness of the civil rights organizations themselves, which were known to

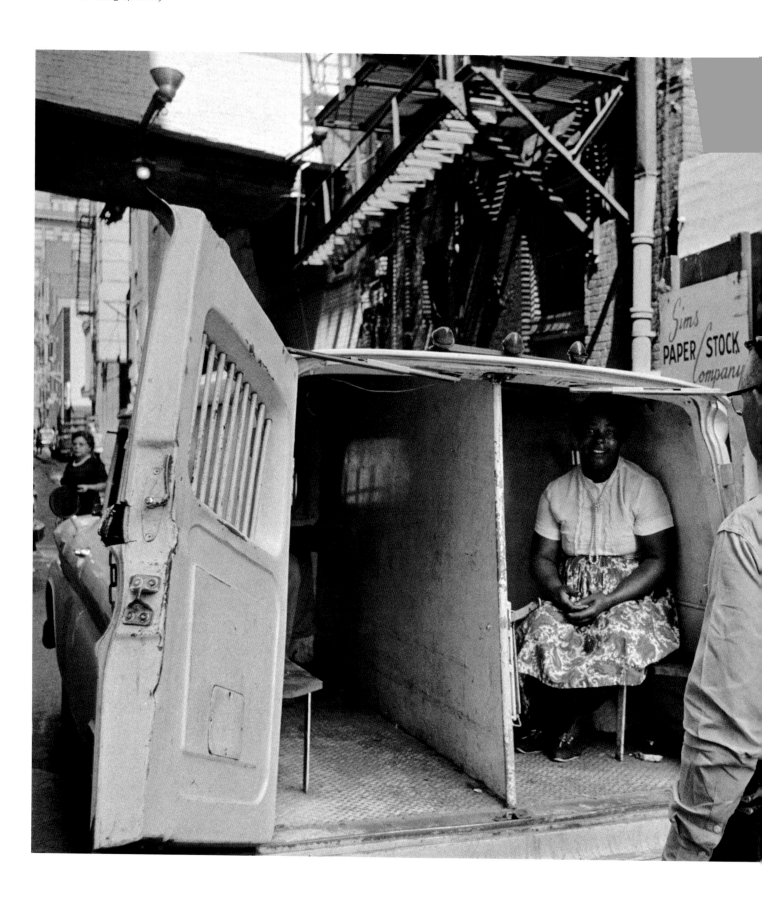

descend on a community for a month, or even a year, of strategic protest before moving on to the next campaign and leaving the community members to deal with the fallout alone.

Fear was not easily dispelled. Some organizers chose to focus their recruiting efforts on young people, who tended to be more hopeful about the future, less susceptible to economic pressures, and less worn down by the indignities of Jim Crow society. Once young people were motivated, their enthusiasm and commitment were instrumental in bringing along reluctant elders. The members of a grassroots group like SNCC would work for years to cultivate local support, talking one-to-one with anyone who would listen to their pitch. All the civil rights organizations targeted local leaders for recruitment, knowing that a few key community stakeholders could connect them with likely supporters and bring respectability to the cause. But by far the most important means of getting people to shed their fear was bringing them together to act in concert. Once blacks felt the fellowship and power of being linked together with supportive peers, once they saw evidence of their power to bring change, it became hard to reinstill in them the old fear.

The woman pictured in this photograph was arrested with a small group of Birmingham picketers protesting the refusal of Loveman's department store to serve black customers at its lunch counter. They carried protest signs with such slogans as "Khrushchev Can Eat Here. Why Can't We?" Well dressed and with arms folded decorously in her lap, the protestor smiles for the white photographer from the back of a police wagon shortly after her arrest. During the spring 1963 protests in the city, the police were frustrated and amazed by the evaporation of black fear of white authority. Whereas blacks had previously gone out of their way to avoid interactions with law-enforcement authorities, they now staged protests certain to draw police attention. Rather than being ashamed by her arrest and the possibility of her photograph appearing on front pages of newspapers in the North, this unidentified woman smiles proudly from the back of the police wagon, evidently comfortable with her decision to challenge Birmingham's racial order.

64. Charles Moore, *Jeering Mob*, Birmingham, Alabama, May 3, 1963. © Charles Moore/Black Star.

The publication history of this photograph illustrates that mainstream media outlets did print photographs from time to time that failed to adhere to the dominant formula for illustrating interactions between black protestors and white authorities. As we have seen ("The Canon," numbers 2–8), blacks typically appeared as victims in the famous photographs of the civil rights struggle. But notice how different is the portrayal of the black youths here. Laughing and apparently relaxed, they chide a middle-aged white police officer who sits astride his motorcycle with billy club in hand. While the image may suggest the potential threat of white violence to viewers today, it also illustrates the excitement, joy, and, perhaps, resolve of black youths.

A version of this photograph appeared in a multipage *Life* magazine article on the racial disturbances in Birmingham in May 1963. The *Life* editors cropped out the billy club, leaving just the joyful protestors wagging their fingers at the officer.[50] The caption suggests how differently white audiences interpreted such scenes of black action in the early 1960s. It read: "Jeering Mob. Waggling their fingers at an officer (left), youthful Negroes taunt police. Provocation like this, to most whites, is a wide-open invitation to full-scale racial warfare." Viewers today may well see the crowd's action as disrespectful, but it does not look threatening, which makes the editor's assertion that "most whites" see the students waggling as "an invitation to full-scale racial warfare" appear overblown. What we need to understand today is that whites in the early 1960s were so accustomed to blacks acting meekly in the presence of law-enforcement authorities that a scene of black youths confronting the police looked not just aberrant but menacing.

A photograph of excited and joyful black youths who showed no fear of the police raised concerns among the many whites who either consciously or unconsciously understood black subservience as the "normal" state. Along these lines, it is telling to note that this photograph is largely unknown today outside the community of civil rights historians. While it was published in a prominent magazine in the early 1960s, it was

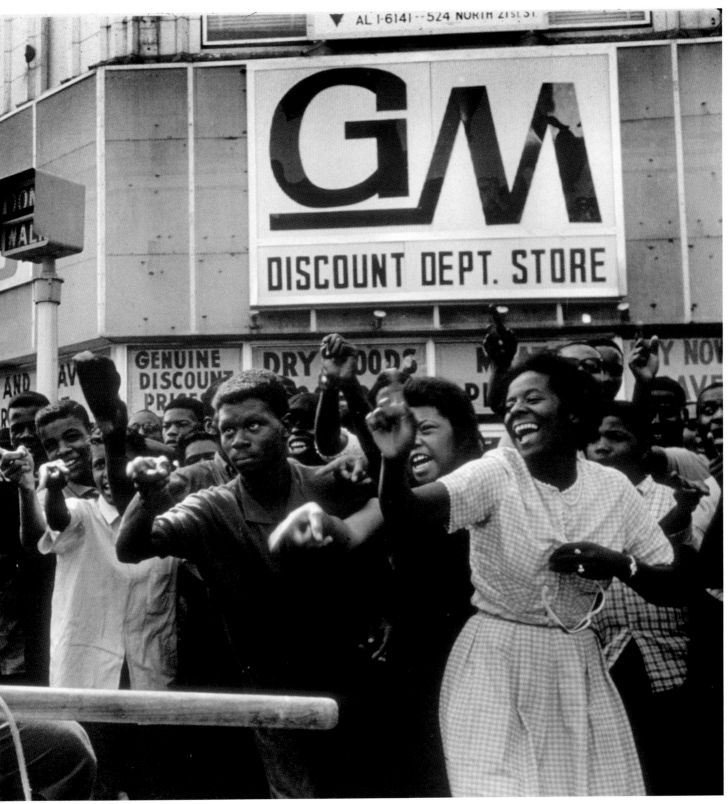

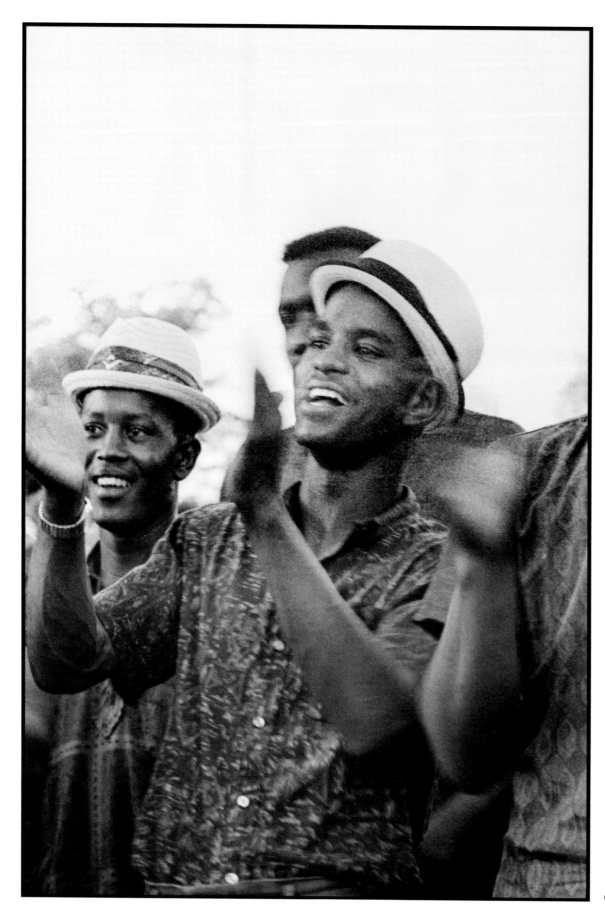

rarely reproduced in subsequent decades. It is a photograph that caused concern among whites and, as a result, quickly dropped from view.

65. Danny Lyon, *Outside a Packed Danville Mass Meeting, the Crowd Responds to Speeches and Singing by SNCC Workers*, Danville, Virginia, June 1963. Courtesy of Danny Lyon and Magnum Photos.

Danville, a textile town in the south of Virginia, was the site of a police rampage against peaceful civil rights protestors on June 10, 1963. Using clubs and fire hoses, the police attacked sixty-five protestors who had done nothing more than march around the city jail and conduct a pray-in at city hall. Forty of the protestors were injured; many of them required attention at the local segregated hospital.

Two days later civil rights activists held a large rally at a local black church on the edge of town. Overflow crowds turned up to support the activists. Many families brought their children to hear speeches by SNCC workers and sing freedom songs. The rally ended abruptly when word spread through the crowd that a large contingent of heavily armed police had assembled up the road with a tank borrowed from the National Guard. SNCC workers waited until the residents had safely dispersed before piling into two cars and heading back to town. They were stopped, threatened, and searched by police, who photographed the activists before letting them go. Shortly thereafter, a grand jury indicted fourteen of the SNCC workers under a nineteenth-century law that made it a capital offence to incite blacks "to acts of war and violence against the white population."

This photograph shows several young men in the crowd at the church rally smiling, clapping, and singing along with SNCC workers. Isolated from history, the scene might well be interpreted as an illustration of carefree blacks enjoying camaraderie and song on a summer's day. But the captured event occurred during a harrowing time, bookended as it was by police violence against demonstrators two days prior and police harassment of peaceful civil rights supporters later that

night. Rather than offering evidence of the untroubled lives of blacks in Danville, it suggests how movement activism brought joy to participants in the midst of terrible violence. Everyone who attended the rally did so because of their concern for the victims of police abuse, out of a desire for reforms in Danville, and with a clear understanding of the attendant risks. The image shows the lengths to which blacks were willing to go in sharing fellowship with sympathetic community members rather than offering evidence of their emotional state.

66. Danny Lyon, *Civil Rights Protestors Sing Freedom Songs as They Are Carted Off to Jail*, Atlanta, Georgia, winter 1963–64. Courtesy of Danny Lyon and Magnum Photos.

Because law enforcement officers are vastly outnumbered by the people they police, they must rely on either the respect of citizens for their authority and the laws they uphold or citizens' fear of their power. Since blacks in the South had little reason to respect laws that were unequally applied and officers who went out of their way to display their unchecked power, fear was all the police had to keeps blacks in line.

As we have seen (numbers 46, 63, and 65), it took time and patient organizing on the part of civil rights organizations to help black communities move beyond their fears. From the perspective of law enforcement officials, one of the most bewildering developments of the era was the speed with which blacks became brave. Police, who were used to encountering blacks made abject in the face of police authority, suddenly confronted activists who refused to call them "Sir" or "Officer," never mind obey their commands. For previous generations of blacks, there was nothing more frightening, dangerous, and shameful than being arrested and sent to jail. Yet as soon as blacks banded together and realized that mass arrests were a means of overloading the system and breaking it down, they came to view incarceration as a badge of honor.

This photograph shows a youthful group of arrested civil rights demonstrators clapping and singing behind the bars of a

police wagon that transports them to jail. With the hard metal door of the police van filling up the entire frame, the photograph presents a clear picture of police power that is obvious to everyone but the activists themselves. They sing to communicate defiance to the drivers and guards and to advertise to anyone along the route they pass that they are neither cowed nor ashamed. Activists would often continue to sing in jail for hours on end, to the exasperation of guards. Even when mattresses were removed from their cells or food and water withheld as punishment, the activists rarely curtailed their songs.

67. Danny Lyon, *Mississippi Freedom Democratic Party Vote*, Mississippi, July or August 1964. Courtesy of Danny Lyon and Magnum Photos.

In preparation for the Democratic National Convention in Atlantic City in August 1964, the Mississippi Freedom Democratic Party (MFDP) held precinct, county, and district meetings that culminated in a state convention. Thwarted from participating in the work of the regular Democratic Party, which the state organization ensured remained all white, the MFDP set about creating a shadow party and primary system (see also numbers 46–48).

The considerable resources expended by the MFDP to build its own system for electing delegates served at least three key purposes. First, the effort demonstrated the seriousness with which Mississippi blacks took their electoral responsibilities, which in turn offered proof to whites in the state and around the country that blacks wanted to participate in elections. At a time when a poll showed that 40 percent of the state's whites did not believe that blacks truly wanted the vote, the organizing efforts of the MFDP telegraphed to the wider community the black desire for the franchise. Second, it allowed the party to distinguish itself from the regular Mississippi Democratic Party: The MFDP was open to all interested citizens, and whites participated in the party and were elected to the ranks of its delegates. Thus, rather than simply practicing reverse discrimination, the MFDP demonstrated its commitment to universal franchise and democracy. This allowed the

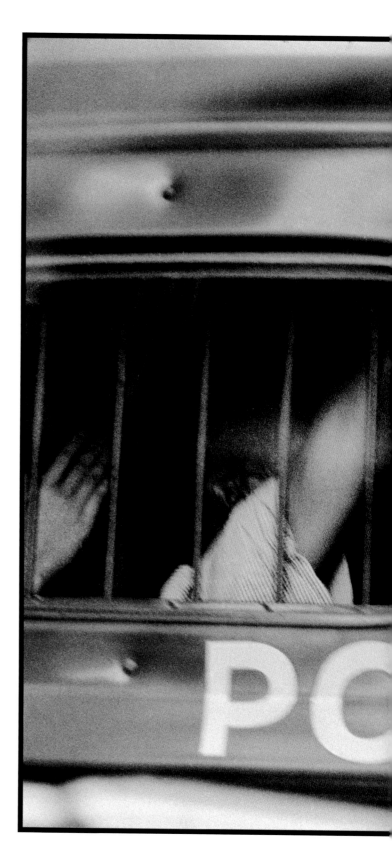

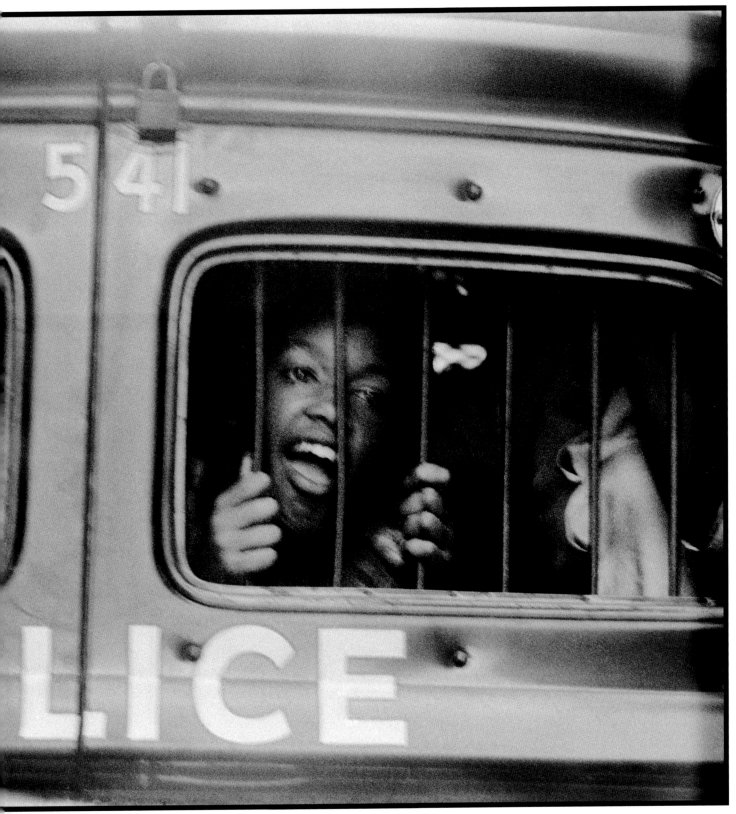

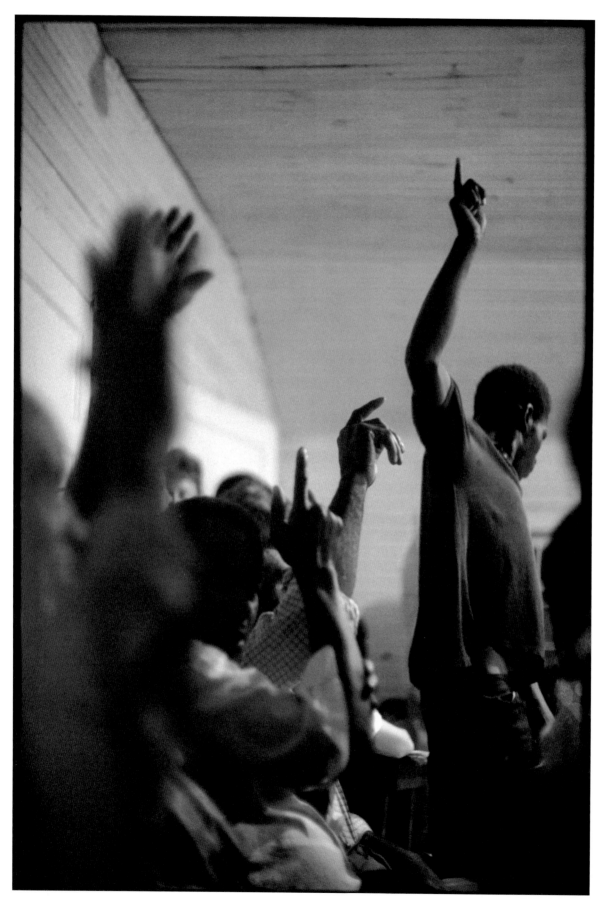

party to plausibly argue before the credentials committee in Atlantic City that they were the duly elected delegates of Mississippi. Third, and most important, the process of building a statewide party served to bind together blacks into an effective force for political change.

This photograph shows citizens raising their hands as they vote in one of the many elections arranged by the MFDP around the state to choose national convention delegates. The photograph does not single out the candidates vying for election or the individual party members casting their votes. Its emphasis is on the sea of hands reaching upward and on the mass of people who came together for the occasion. Up until the 1960s most Mississippi blacks lived in isolated communities with few organizations capable of uniting them and harnessing their power as a group. The MFDP was a new kind of organization that galvanized the collective power of individuals to bring about significant change. As two MFDP leaders explained in 1966, statewide organizing efforts were now "a basic tenet of MFDP organization and operation. [The] entire Negro community, all 45 percent of the vote it represents, must be united in an independent, radically democratic organization so as to be able to act politically from a position of maximum strength. Without this kind of solid community organization the vote, when it comes, will be close to meaningless as an implement of necessary social change."[51] In "neglecting" individuals, the photograph pictures the power of people united in common cause.

68. Frederick C. Baldwin, *Waving Certificates of Courage, First African Baptist Church Basement*, Savannah, Georgia, 1964. © Frederick C. Baldwin.

Churches had long been centers of civil rights activism. Though there were certainly black churches steadfastly opposed to civil rights involvement, many preachers were leaders in civil rights organizations and raised issues of equality with their congregants in sermons that pushed them to activism. Even less politically active clergy routinely allowed activists to use their sanctuaries for meetings. The local church was almost certainly the most stable, respected, and safe institution in black communities during the 1950s and 1960s. The famous activism of Montgomery, Birmingham, and Selma would have been inconceivable if not for the support of local church leaders. The same was true of lesser-known civil rights protests, such as those in Savannah, Georgia.

Savannah's First African Baptist Church became a center of civil rights activism in the 1940s when Dr. Ralph Mark Gilbert, a vocal NAACP supporter and charismatic speaker, was hired as its pastor. He not only reestablished a defunct NAACP chapter in the city but also served as its president for nearly a decade. Gilbert was instrumental in registering blacks to vote and in supporting the election of white reformers to the mayor's office and city council. His electoral efforts helped ensure that when the nonviolent civil rights protestors of the 1960s took to the streets, they confronted a moderate municipal government that had little appetite for violent confrontations.

Savannah's civil rights protestors forced business and political leaders to negotiate the end of segregated facilities after a damaging eighteen-month-long black boycott of local businesses that ran from March 1960 to October 1961. Because the desegregation of city stores proceeded without dramatic clashes, the photographs chronicling the protests are of a different character than the famous civil rights images. Frederick Baldwin, the photographer who shot this image,

photographs show long lines of marchers silhouetted against the sky; well-known white actors, singers, and intellectuals who joined the procession in solidarity; or unidentified weary, and often damp, black marchers with worn-out shoes.

This photograph captures a less frequently documented aspect of the march: its humor. A number of the younger black marchers spread generous quantities of zinc oxide across their faces—to protect their skin from sunburn, to be sure, but also to make a humorous reference to blacks in "whiteface." In doing so, they played off of the longstanding minstrel tradition of white entertainers "blacking up" their faces and reddening their lips. White minstrels in blackface played African Americans on stage in satirical skits and dances for white audiences. Such performances were widely seen as demeaning in the black community and, while declining in frequency by the second half of the twentieth century, remained a feature of U.S. society.

The many youths in whiteface that Herron documented commented ironically on this convention by lightening their skin. But rather than merely reversing the minstrel formula, they neither ridiculed white people nor indicated a desire to be white; instead, they simply expressed their determination to exercise the prerogatives typically enjoyed by white Americans: moving freely through the state, expressing their political views, and, ideally, pushing toward a day when their right to vote would be accepted by all Americans and protected by state and federal authorities.

70. William Lovelace, *Supporters of the Selma to Montgomery Marchers*, March 21–25, 1965, Alabama. Hulton Archive/Getty Images.

The Selma-to-Montgomery civil rights march followed U.S. Route 80 through Dallas, Lowndes, and Montgomery counties. As it passed through Lowndes County, the route wended its way through rural stretches of Alabama populated with disenfranchised, landless black residents, half of whom lived in poverty. In 1965 just 19 percent of voting-age blacks were registered to vote in Alabama—the lowest black registration rate after Mississippi. In Lowndes County, where there were 5,000 blacks of voting age at the start of 1965, not one black citizen was registered. In many ways the county was a throwback to the previous century.

This photograph shows a group of unidentified local residents on a front porch offering applause and encouragement to the passing marchers. The women's neat, respectable outfits offer a contrast to the weathered clapboard siding behind them. Many families along the route waited for hours to greet protestors in their "Sunday best," so acknowledging the importance of the occasion. Local residents encouraged marchers, brought them food and drink, rushed out to shake their hands, and, occasionally, joined in the march themselves. For black onlookers, the march was a revelation. Residents were thrilled that a large contingent of black marchers was able to defy the wishes of the governor and local law-enforcement authorities and stage their protest; they were excited at the prospect of seeing national civil rights leaders pass by their homes; and they were pleased that their right to vote was increasingly of concern to a national audience. For many residents of rural Alabama, whose interactions with whites were limited and always hierarchical, it was an astonishing procession that brought white and black marchers together in support of black voting rights.

The well-known clergymen, civil rights leaders, actors, and singers who flew in for the famous march from Selma to Montgomery had their eyes primarily fixed on the national stage. Their efforts, nonetheless, had a profound impact on local people who could hardly have imagined such an unlikely

70

procession passing by their homes just months before. The photographic record of the civil rights movement is overwhelmingly one that chronicles the participants in marches and protests; this photographs reminds us that the most effective of such activism was rooted in community support.

71. Dozier Mobley, *Mrs. Annie Maude Williams, 44, of Selma, Alabama, Held Her Certificate of Eligibility to Vote*, August 10, 1965. AP Photo.

Shortly after President Johnson signed the Voting Rights Act into law in the summer of 1965, the federal government initiated a multipronged attack on black disenfranchisement. Federal examiners were appointed, trained, and sent to states with clear records of discriminatory voting practices. The states initially covered were Alabama, Georgia, Louisiana, Mississippi, South Carolina, Virginia, and many of the counties in North Carolina. Extensions of the act in 1970, 1975, 1982, and 2006 added states and counties with histories of disenfranchising minority voters, including some in the North.[53] Examiners were empowered to replace recalcitrant local officials and register as many black citizens as possible. The act suspended all "tests and devices" previously used to screen applicants, such as examinations of literacy and constitutional knowledge and signed affidavits attesting to one's moral character, and it outlawed poll taxes, empowering the Justice Department to file suits to halt their use in Alabama, Mississippi, Texas, and Virginia. Within days of the signing, examiners were at work in Dallas County, an Alabama county that had produced some of the most famous scenes of black voter rights activism. As a consequence of federal intervention and intensive grassroots organizing efforts, the previously dismal registration rates for blacks in Alabama rose to just over 51 percent in 1966.

A white photographer, Dozier Mobley, took this portrait of a new voter. It shows recently registered forty-four-year-old Annie Maude Williams beaming for the camera as she displays with both hands the small slip of paper that attests to her eligibility to vote. She registered with an examiner on

10 James R. Ralph Jr., *Northern Protest: Martin Luther King, Jr., Chicago, and the Civil Rights Movement* (Cambridge, MA: Harvard University Press, 1993), 123.

11 The inclusion of a photographer in "The Canon" should not be taken as a sign that his or her work consistently framed whites as active and blacks as passive. For example, I have included Fernandez's image of counterprotestors in Chicago here because of its fame, even though his lesser-known photograph reproduced in number 38 is more indicative of his work overall.

12 "A Typical Negro," *Harper's Weekly,* July 4, 1863, 429–30.

13 Mary Niall Mitchell, *Raising Freedom's Child: Black Children and Visions of the Future after Slavery* (New York: New York University Press, 2008), 58–62.

14 "Negroes Urge U.S. Troops in Alabama," *New York World-Telegram and Sun,* September 16, 1963, 1–2.

15 "The Spectacle of Racial Turbulence in Birmingham: They Fight a Fire That Won't Go Out." *Life*, 54:20 (May 17, 1963), 32.

16 Erina Duganne, *The Self in Black and White: Race and Subjectivity in Postwar American Photography* (Hanover, NH: Dartmouth College Press, 2010), 127.

17 Matt Herron, interview with author, San Rafael, CA, June 8, 2012.

18 "The Strange Trial of the Till Kidnappers," *Jet,* October 6, 1955, 9.

19 McWhorter, *Carry Me Home,* 374; "Violence in Birmingham," *Washington Post,* May 5, 1963, E-6; Mike Gold [Itzok Isaac Granich], "Change the World," *The Daily Worker,* May 26, 1963, 4.

20 Alvin Adams, "Picture Seen around the World Changed Boy's Drop-Out Plan," *Jet,* October 10, 1963, 26–7.

21 "Dirty Dog Tactics Used in Birmingham, Ala.," *Pittsburgh Courier,* May 18, 1963, 3.

22 Malcolm X, *Malcolm X Speaks* (New York: Grove Press, 1994), 16; James Forman, *The Making of Black Revolutionaries* (Washington, DC: Open Hand Publishing, 1985), 334; Anne Moody, *Coming of Age in Mississippi* (New York: Bantam Dell, 2004), 335.

23 David J. Garrow, *Bearing the Cross: Martin Luther King, Jr., and the Southern Christian Leadership Conference* (New York: Quill, 1986), 266.

24 Lewis and D'Orso, *Walking with the Wind,* 220.

25 Danny Lyon, *Memories of the Southern Civil Rights Movement* (Chapel Hill: University of North Carolina Press, 1992), 84.

26 Charles M. Payne, *I've Got the Light of Freedom: The Organizing Tradition and the Mississippi Freedom Struggle* (Berkeley and Los Angeles: University of California Press, 1995), 295.

27 "Houston Negroes Press Campaign: New Leader Expands Drive for School Integration," *New York Times,* May 16, 1965, 58.

28 Charmian Reading, interview with author, New York, August 18, 2011.

29 A number of scholars have argued that the blatant efforts of whites to disenfranchise minority voters in the twentieth century have continued covertly in the twenty-first century. Depending on one's political outlook, contemporary state voter identification laws are more significant for preventing voter fraud or for suppressing the vote of the poor and ethnic and racial minorities. For a study concluding that Georgia's 2007 requirement for registrants to present government-issued photo ID to vote suppressed the legitimate vote without disproportionately impacting ethic or racial minorities, see M. V. Hood and Charles S. Bullock, "Much Ado About Nothing? An Empirical Assessment of the Georgia Voter Identification Statute," *State Politics & Policy Quarterly* 12:4 (December 2012): 394–414.

30 Laughlin McDonald, Michael B. Binford, and Ken Johnson, "Georgia," in Chandler Davidson and Bernard Grofman, eds., *Quiet Revolution in the South: The Impact of the Voting Rights Act, 1965–1990* (Princeton, NJ: Princeton University Press, 1994), 76–77.

31 Matthew J. Countryman, *Up South: Civil Rights and Black Power in Philadelphia* (Philadelphia: University of Pennsylvania Press, 2005), 205.

32 Robert E. Johnson, "Black Power: What it Really Means," *Jet,* July 28, 1966, 16–21.

33 Amy Bass, *Not the Triumph but the Struggle: The 1968 Olympics and the Making of the Black Athlete* (Minneapolis: University of Minnesota Press, 2002), 240; "Raised Black Fists," *Life,* November 1, 1968, 64-C.

34 "Nurse Midwife Maude Callen Eases Pain of Birth, Life and Death," *Life,* December 3, 1951, 134. We know from the research of Glenn Willumson that *Life* originally commissioned a photo-story from Smith on "the life of [an anonymous] rural midwife and the role an enlightened white woman, Laura Blackburn, had played in the establishment of one of the finest midwife programs in the United States." However, after Smith met dedicated and effective black midwifes, and witnessed the racism of both the Ku Klux Klan and white hospital staff, he shifted the article's focus to the life and work of a singular black midwife, Maude Callen. See Glenn G. Willumson, *W. Eugene Smith and the Photographic Essay* (Cambridge, UK: Cambridge University Press, 1992), 148–57.

35 Henry Hampton and Steve Fayer, eds., *Voices of Freedom: An Oral History of the Civil Rights Movement from the 1950s through the 1980s* (New York: Bantam Books, 1990), 25–26.

36 Albert C. "Buck" Persons, "How Images Are Created," in *The True Selma Story: Sex and Civil Rights* (Birmingham, AL: Esco Publishers, Inc., 1965), 16, 18; John Britton, "Victory in Birmingham Can Be Democracy's Finest Hour," *Jet,* May 2, 1963, 15.

37 Kay Mills, *This Little Light of Mine: The Life of Fannie Lou Hamer* (Lexington: University of Kentucky Press, 2007), 19–20.

38 Ibid., 120–21.

39 Lewis and D'Orso, *Walking with the Wind,* 291–92.

40 David J. Garrow, *Protest at Selma: Martin Luther King, Jr., and the Voting Rights Act of 1965* (New Haven: Yale University Press, 1978), 61.

41 Richard Hall, "A Stir of Hope in Mound Bayou," *Life,* March 28, 1969, 76.

42 "Troublemaker for a School," *Life,* September 10, 1956, 46; "Boldest Move Yet to Enforce Integration," *Life,* December 17, 1956, 40.

43 Hampton and Fayer, *Voices of Freedom,* 54.

44 John H. Britton, "Cute Youngster Determined," *Jet,* May 23, 1963, 19.

45 *Jet,* May 16, 1963, 33.

46 Diane McWhorter, *Carry Me Home: Birmingham, Alabama, the Climactic Battle of the Civil Rights Revolution* (New York: Simon & Schuster, 2001), 367.

47 Thierry Devos and Mahzarin R. Banaji, "American = White?" *Journal of Personality and Social Psychology* (88:3): 2005, 447–466.

48 Henry Louis Gates, *The Signifying Monkey: A Theory of African-American Literary Criticism* (New York: Oxford University Press, 1989).

49 "Songs Seen as Vital in Albany Demonstrations," *Chicago Daily Defender,* August 22, 1962, 16.

50 "The Spectacle of Racial Turbulence in Birmingham: They Fight a Fire That Won't Go Out." *Life,* 54:20 (May 17, 1963), 26–36.

51 Lawrence Guyot and Mike Thelwell, "The Politics of Necessity and Survival in Mississippi, No. 2, 1966," in Esther Cook Jackson, ed., *Freedomways Reader: Prophets in Their Own Country* (Boulder, CO: Westview Press, 2000), 106–07.

52 Telfair Museum of Art, *Freedom's March: Photographs of the Civil Rights Movement in Savannah by Frederick C. Baldwin* (Savannah: Telfair Books, 2008), 20.

53 In June 2013, by a 5-4 vote, the U.S. Supreme Court found unconstitutional the coverage formula in section 4 of the Voting Rights Act, determining which states were required to receive preclearance from federal authorities for making changes to laws that affect voting. While not invalidating section 5 of the act, which set out the preclearance requirement itself, the ruling severely curtailed the most important legislative achievement of the civil rights era.

54 "Negroes Begin to Register: Many Are Put on Lists in Racial Hotspots," *Chicago Tribune,* August 11, 1965, 1.

Bob Adelman (b. 1930) was born in Brooklyn and earned a BA from Rutgers, studied law at Harvard, and earned an MA in philosophy from Columbia. He took classes with the art historian Meyer Shapiro and the art director and graphic designer Alexey Brodovitch. He subsequently worked as a volunteer photographer for CORE and SNCC in the early 1960s. While he is known for chronicling the art and literary scene in New York, his most-reproduced photographs record the work of black activists for social and racial equality in the 1960s. His photographs have appeared in *Time*, *Life*, *New York Times Magazine*, *Stern*, *Look*, and *Paris Match*. His most recent book of civil rights photography is *Mine Eyes Have Seen: Bearing Witness to the Civil Rights Struggle* (2007).

Frederick C. Baldwin (b. 1929) was born in Lausanne, Switzerland, the son of an American diplomat. He was a self-taught photographer determined to make a living as a freelancer. Baldwin began modestly as a portrait photographer in Savannah, Georgia, in the early 1950s, after he was discharged from military service at the end of the Korean War. By 1960 he had secured sponsorship from the New York Zoological Society to embark on a scientific expedition to northern Norway to film polar bears underwater; the resulting photographs appeared in *Life* to much acclaim. In 1961 Baldwin was in Baja California in Mexico making underwater photos of marlin fishing in an homage to Ernest Hemingway, whom he had met in Cuba some years before. In 1963 Baldwin worked for Attorney General Robert Kennedy, photographing street gangs and drug users through New York's Mobilization for Youth program. In 1963–64 he supported the civil rights movement as a volunteer photographer for SCLC in Savannah.

Dr. Doris A. Derby (b. 1939) earned a BA from Hunter College in 1961. After graduation she taught elementary school in Yonkers before joining SNCC in 1962. For the next decade she worked in Georgia, Alabama, Louisiana, and Mississippi as an educator, community organizer, administrator, Head Start teacher, documentary photographer, and filmmaker. Between 1972 and 1980 she earned a PhD in cultural and social anthropology, specializing in African American studies, at the University of Illinois

at Urbana-Champaign. She subsequently taught or worked in administrative roles at the University of Wisconsin–Madison; the University of Wisconsin–Milwaukee; and Georgia State University. Her best-known civil rights photographs depict dignified black farmworkers in Mississippi.

Benedict J. Fernandez (b. 1936) was born in East Harlem. He was a self-taught photographer who gained experience as a child working in photographic labs. While employed as a crane operator at the Bethlehem Steel Shipyard in Hoboken, New Jersey, he joined camera clubs and began winning competitions. In 1963 he transitioned into a career as a professional photographer. Impressed with Fernandez's work, Alexey Brodovitch encouraged the photographer to become the darkroom technician and manager at the Parsons School of Design. Fernandez founded the Photo Film Workshop, which taught photography to disadvantaged youths for free, and, later, designed and chaired the photography major at Parsons. Fernandez photographed an eclectic array of documentary subjects over his long career in the United States, Europe, Japan, and China. Some of his most famous photographs capture the civil rights and antiwar activism of the 1960s. He has received awards from the Guggenheim and Fulbright Foundations, and National Endowment of the Arts.

Bob Fitch (b. 1939) grew up in Berkeley, California, in a conservative Christian family, but he found himself drawn to the area's radical community of Socialist and Communist Party members. He originally trained to be an engineer and, then, a Protestant minister, but settled on a career as an activist-photographer when he landed a job in the mid-1960s as a photographer for the Glide Foundation in San Francisco. Shortly thereafter SCLC hired him as a staff photographer. With SCLC he travelled extensively throughout Alabama, Mississippi, and Georgia documenting the day-to-day activities of movement leaders and activists. He routinely mailed his photographs from this period to black publications that were unable to afford their own staff photographers. After Dr. Martin Luther King Jr.'s assassination, Fitch covered the organizing efforts of Cesar Chavez and the United Farm Workers of America; Dorothy Day and the Catholic Worker Movement; Dan

and Phillip Berrigan's war resistance activities; and David Harris and Joan Baez's draft resistance work.

Matt Herron (b. 1931) graduated cum laude from Princeton University with a BA in English in 1953. He was a largely self-taught photographer who studied privately with Minor White, a poet and photographer who cofounded *Aperture* magazine. Herron worked as a freelance photographer in the North before moving to Jackson, Mississippi, in the summer of 1963 to organize against segregation. He worked in coordination with SNCC and published in the major picture magazines of the era, including *Life*, *Look*, *Newsweek*, *Time*, and the *Saturday Evening Post*. In 1964 he founded and directed the Southern Documentary Project, a team of six photographers that attempted to document the process of social change in the South. He has actively advanced social justice and environmental causes his entire adult life. In 2011 he curated *This Light of Ours: Activist Photographers of the Civil Rights Movement* at the Center for Documentary Expression and Art in Salt Lake City.

Bill Hudson (1932–2010) was born in Detroit and began his three-decade-long career in photojournalism as an army photographer during the Korean War in 1949. He subsequently worked for the *Press-Register* in Mobile, Alabama, and the *Chattanooga Times* before joining the Associated Press in Memphis in 1962. He left the AP in 1974 to join United Press International. His best-known photographs capture the civil rights movement, particularly the violent clashes in Birmingham and Selma, Alabama, in the mid-1960s.

Danny Lyon (b. 1942) is a self-taught photographer who was born in Queens and earned a BA in history from the University of Chicago in 1963. He began his photographic career as the first staff photographer of SNCC. His photographs provide a chronicle of the grassroots work of SNCC in rural communities throughout the South, preserving a view of activism that was of little interest to the mainstream media. He went on to document and publish photo books on a motorcycle gang in Illinois (1967), the clearing of lower Manhattan to prepare for the building of the World Trade Center towers in New York (1969), and prisoners in Texas (1971). His civil rights photographs first reached a mass audience through their use in SNCC propaganda posters and their circulation in Lorraine Hansberry's *The Movement: Documentary of a Struggle for Equality* (1964). His photographs are held in major museum collections around the world.

Charles Moore (1931–2010) was born in Hackleburg, Alabama, the son of a white Baptist minister who spoke out against racism and occasionally preached in black churches. Moore served three years in the marines as a photographer before training at the Brooks Institute of Photography in Santa Barbara, California. He began his professional career in Alabama, working for both the *Montgomery Advertiser* and the *Montgomery Journal*. In 1962 he became a freelancer with the Black Star picture agency in New York City. He is best known for his photographs covering the arrest of Dr. Martin Luther King Jr. in Montgomery, the white riots at the University of Mississippi, and the clashes between Bull Connor and antisegregationist demonstrators in Birmingham.

Charmian Reading (b. 1931) was born in Toronto, Ontario. She earned an honours BA in philosophy and English from the University of Toronto in 1952. She started graduate work in philosophy but abandoned it when she moved to New York City in 1955. There she began to study photography, including a course with Alexey Brodovitch. In the mid-1960s Reading embarked on a career as a freelance photographer covering art and dance in New York City for Toronto newspapers. Shortly thereafter she shifted to issues of social concern, as she documented the growing protest movement in the United States against the Vietnam War. During the late 1960s she travelled throughout the South with the aid of contacts in SNCC to document poverty and the black civil rights movement. Her photographs illustrated articles in the 1960s on poverty in Alabama and Appalachia, Meredith's March against Fear, Che Guevara, and black lung disease, though much of her work remains unpublished.

I drew heavily from the observations, research, and analysis of period activists, observers, and contemporary historians in writing this catalogue. The following works were indispensible to my project.

Arsenault, Raymond. *Freedom Riders: 1961 and the Struggle for Racial Justice*. New York: Oxford University Press, 2007.

Baldwin, James. *The Fire Next Time*. New York: Vintage, 1992.

Berger, Martin A. *Seeing through Race: A Reinterpretation of Civil Rights Photography*. Berkeley and Los Angeles: University of California Press, 2011.

Berger, Maurice. *For All the World to See: Visual Culture and the Struggle for Civil Rights*. New Haven: Yale University Press, 2010.

Branch, Taylor. *Parting the Waters: America in the King Years, 1954–63*. New York: Simon & Schuster, 1988.

_____. *Pillar of Fire: America in the King Years, 1963–65*. New York: Simon & Schuster, 1998.

Charron, Katherine. *Freedom's Teacher: The Life of Septima Clark*. Chapel Hill: University of North Carolina Press, 2012.

Cobb, Charles E., Jr. *This Light of Ours: Activist Photographers of the Civil Rights Movement*. Jackson: University of Mississippi Press, 2012.

Coles, Robert. *A Study in Courage and Fear*. Vol. 1 of *Children of Crisis*. Boston: Little, Brown and Company, 1967.

Countryman, Matthew J. *Up South: Civil Rights and Black Power in Philadelphia*. Philadelphia: University of Pennsylvania Press, 2005.

Cox, Julian. *Road to Freedom: Photographs of the Civil Rights Movement, 1956–1968*. Atlanta: High Museum of Art, 2008.

Davidson, Chandler, and Bernard Grofman, eds. *Quiet Revolution in the South: The Impact of the Voting Rights Act, 1965–1990*. Princeton, NJ: Princeton University Press, 1994.

Duganne, Erina. *The Self in Black and White: Race and Subjectivity in Postwar American Photography*. Hanover, NH: Dartmouth College Press, 2010.

Fairclough, Adam. *To Redeem the Soul of America: The Southern Christian Leadership Conference and Martin Luther King, Jr.* Athens: University of Georgia Press, 1987.

Forman, James. *The Making of Black Revolutionaries*. Washington, DC: Open Hand Publishing, 1985.

Formisano, Ronald P. *Boston Against Busing: Race, Class, and Ethnicity in the 1960s and 1970s*. Chapel Hill: University of North Carolina Press, 2003.

Garrow, David J. *Bearing the Cross: Martin Luther King, Jr., and the Southern Christian Leadership Conference*. New York: Quill, 1986.

_____. *Protest at Selma: Martin Luther King, Jr., and the Voting Rights Act of 1965*. New Haven: Yale University Press, 1978.

Hampton, Henry, and Steve Fayer, eds. *Voices of Freedom: An Oral History of the Civil Rights Movement from the 1950s through the 1980s*. New York: Bantam Books, 1990.

Hansen, Drew D. *The Dream: Martin Luther King, Jr., and the Speech that Inspired a Nation*. New York: HarperCollins, 2003.

Jackson, Esther Cook, ed. *Freedomways Reader: Prophets in Their Own Country*. Boulder, CO: Westview Press, 2000.

Jeffries, Hasan Kwame. *Bloody Lowndes: Civil Rights and Black Power in Alabama's Black Belt*. New York: New York University Press, 2010.

King, Martin Luther, Jr. *Why We Can't Wait*. New York: Harper & Row, 1964.

Levine, Ellen. *Freedom's Children: Young Civil Rights Activists Tell Their Own Stories*. New York: Puffin Books, 2000.

Lewis, John, with Michael D'Orso. *Walking with the Wind: A Memoir of the Movement*. New York: Harcourt Brace & Company, 1998.

Lyon, Danny. *Memories of the Southern Civil Rights Movement*. Chapel Hill: University of North Carolina Press, 1992.

Marable, Manning. *Freedom: A Photographic History of the African American Struggle*. New York: Phaidon Press, 2005.

McDonald, Laughlin. *A Voting Rights Odyssey: Black Enfranchisement in Georgia*. Cambridge: Cambridge University Press, 2003.

McWhorter, Diane. *Carry Me Home: Birmingham, Alabama, the Climactic Battle of the Civil Rights Revolution*. New York: Simon & Schuster, 2001.

Metress, Christopher, ed. *The Lynching of Emmett Till: A Documentary Narrative*. Charlottesville: University of Virginia Press, 2002.

Mills, Kay. *This Little Light of Mine: The Life of Fannie Lou Hamer*. Lexington: University of Kentucky Press, 2007.

Mitchell, Mary Niall. *Raising Freedom's Child: Black Children and Visions of the Future after Slavery*. New York: New York University Press, 2008.

Moody, Anne. *Coming of Age in Mississippi*. New York: Dell Books, 1968.

Payne, Charles M. *I've Got the Light of Freedom: The Organizing Tradition and the Mississippi Freedom Struggle*. Berkeley and Los Angeles: University of California Press, 1995.

Raiford, Leigh. *Imprisoned in a Luminous Glare: Photography and the African American Freedom Struggle*. Chapel Hill: University of North Carolina Press, 2011.

Ralph, James R., Jr. *Northern Protest: Martin Luther King, Jr., Chicago, and the Civil Rights Movement*. Cambridge, MA: Harvard University Press, 1993.

Ransby, Barbara. *Ella Baker and the Black Freedom Movement: A Radical Democratic Vision*. Chapel Hill: University of North Carolina Press, 2003.

Rustin, Bayard. *Down the Line: The Collected Writings of Bayard Rustin*. Chicago: Quadrangle Books, 1971.

Sugrue, Thomas J. *Sweet Land of Liberty: The Forgotten Struggle for Civil Rights in the North*. New York: Random House, 2008.

Telfair Museum of Art. *Freedom's March: Photographs of the Civil Rights Movement in Savannah by Frederick C. Baldwin*. Savannah, GA: Telfair Books, 2008.

Thornton, J. Mills, III. *Dividing Lines: Municipal Politics and the Struggle for Civil Rights in Montgomery, Birmingham, and Selma*. Tuscaloosa: University of Alabama Press, 2002.